IMAGES
of America

EARLY LONG BEACH

IMAGES
of America

EARLY LONG
BEACH

Gerrie Schipske

ARCADIA
PUBLISHING

Published by Arcadia Publishing
Charleston, South Carolina

Printed in the United States of America

Library of Congress Control Number: 2011921754

For all general information, please contact Arcadia Publishing:
Telephone 843-853-2070
Fax 843-853-0044
E-mail sales@arcadiapublishing.com
For customer service and orders:
Toll-Free 1-888-313-2665

Visit us on the Internet at www.arcadiapublishing.com

This book is dedicated to our first grandchild, Brenda,
who has just begun making her own history.

CONTENTS

ACKNOWLEDGMENTS

A special thank you to the thoughtful, dedicated librarians of the Long Beach Public Library system who help preserve and cherish the history of Long Beach. I also give a special thank you to the volunteers of the Friends of the Long Beach Public Library and the Long Beach Public Library Foundation, who work tirelessly to support the efforts of these librarians.

Unless otherwise noted, images are from the personal collection of the author.

INTRODUCTION

Few other cities can boast of the natural assets and events that the city of Long Beach, California, can and that have shaped the first 50 years of its history.

The city has been known by many names during this period, such as the following: Ranchos Los Alamitos and Los Cerritos, American Colony, Cerritos Colony, Willmore City, Fastest Growing City in the Nation, the Willows, Queen of the Beaches, Tent City, the Ideal Home City, the Playground of the World, the Home of Industry, Clam City, the National Health Resort, and the Wonder City of the Pacific Southwest. But the name Long Beach, which was suggested by Belle Lowe, the wife of the town's first postmaster (appointed by Pres. Grover Cleveland in 1885), is the one that has survived.

Lowe suggested the name in 1884 to the land syndicate that was attempting to market the area, arguing that it reflected the town's most popular asset—eight-plus miles of wide-open beach along the town's southern border. Lowe's suggestion won over Crescent City, a name advocated because of the shape of the area's coastline.

It may have been a coincidence (or the expansion west of the railroads), but the naming of the town as Long Beach seemed to be just what was needed to turn this sleepy seaside community into a thriving municipality. Not that others before hadn't tried to do the same; they had, particularly men (and, in many cases, their wives) such as Manuel Nieto, John Temple, Abel Stearns, Benjamin and Dr. Thomas Flint, Llewellyn Bixby, Jotham Bixby, John Bixby, I.W. Hellman, and William Erwin Willmore.

After the Spanish took the land from the Tongva native people (later known as the Gabrielinos because of their affiliation with the Mission San Gabriel Arcángel), they distributed it as land grants. In 1784, Gov. Pedro Fages granted all the land between the San Gabriel (now Los Angeles) and Santa Ana Rivers to Manuel Nieto for his service as a Spanish soldier. The size of the land grant was subsequently reduced by Gov. Diego de Borica so as not to infringe upon the area occupied by the Mission San Gabriel. Nieto worked the land (referred to as Rancho Los Coyotes), raising cattle, sheep, and horses. Upon Nieto's death, the land was divided into following five ranchos: Los Coyotes, Los Cerritos, Santa Gertrudes, Las Bolsas, and Los Alamitos.

In a succession of real estate transactions, portions of the land within Ranchos Los Cerritos owned by John Temple were sold to Flint, Bixby & Company in 1866, and eventually, parts were sold off in lots to settlers and speculators who formed colonies.

The first of these colonies in the Long Beach area was the Cerritos Colony Tract near Willow Street and Pico Avenue. Settled in 1878 by James A. Teel, it was also the site of the Cerritos School, the first of its kind in the area.

The Southern Pacific Railroad promoted migration to the West Coast through the California Immigrant Union, thereby securing "a good class of foreigners from Europe, Canada, and eastern states." The California Immigrant Union (CIU) southern manager, William Erwin Willmore, secured 4,000 acres of Rancho Los Cerritos from Jotham Bixby and set out to establish the American Colony Tract in 1880.

Willmore retained Capt. C.T. Healey to survey the land for a town site. Healey drew the baseline at Second Street (Broadway) and placed Magnolia Avenue at the western boundary, Tenth Street as the northern boundary, and Alamitos Avenue as the eastern boundary. It was laid out to be eight blocks wide and 10 blocks from the ocean. Ten blocks were dedicated for a park (Pacific Park) and eight to churches, schools, a library, and a college. North of the town site would be for farming. At the suggestion of a Los Angeles newspaper reporter, American Colony was renamed Willmore City in 1882.

Although the end of the Civil War and the expansion of the railroads spurred migration to the West Coast, Willmore had great difficulties attracting buyers to his colony. The area lacked amenities for tourists and there was no transportation across the three-mile gap from the terminus of the railroad to the town except for a horse-drawn American Colony railroad that often required passengers to get out and push.

By 1884, Willmore City failed, sending its founder to Arizona, where he became ill due to sunstroke. Broken, Willmore returned to Long Beach, where he died in 1901.

From 1884 until 1897, the area changed dramatically. Willmore City became Long Beach. The Long Beach School District, Long Beach High School, and the newspaper *Long Beach Journal* were established. The Long Beach Hotel was built on the bluff, and Judge Robert Maclay Widney provided a steam engine for the transportation. The Methodist Resort Association located its Chautauqua Assembly and Tabernacle at Third Avenue and American Street, bringing thousands of members. Richard Loynes opened his brick-making business.

The town built its first pier at the end of Magnolia Avenue. A library and bank were opened. The first franchises were given for an electric-lighting plant (managed by a woman), a water company, and a telephone service. A post office was established in W.W. Lowe's general store at Ocean and Pine Avenues.

Long Beach has the distinction of being one of the only cities in California to have been incorporated, disincorporated, and incorporated again in a span of eight years. By 1921, Long Beach voted in three types of city government: mayor-council, commissioners, and council–city manager. The council–city manager form remains in place.

On January 30, 1888, 106 residents voted in favor of incorporation and the election of five city trustees. Among the first acts of the city government was a tax on dogs and the adoption of an ordinance banning gambling and saloons. The boundaries of the city were expanded. The incorporation did not last long. In 1896, 132 residents voted in favor of disincorporation, accusing the council of "doing nothing but copying Los Angeles." Fearing that disincorporation would open up the town to saloons and allow the town's assets to fall into disrepair, a new election was held on December 1, 1897, with 237 residents voting for incorporation.

The Southern Pacific Railroad connected Long Beach with its San Pedro line, and in 1889, the Los Angeles Terminal Railroad line was put through to Rattlesnake Island (Terminal Island).

From its earliest days, the residents of Long Beach valued both schools and libraries. A small reading room with books provided by the Women's Temperance Union was housed in a shack in 1896. When the first city hall was built in 1899, the library occupied the lower floor. Industrialist Andrew Carnegie gave $30,000 to the City of Long Beach to build a library in 1908 in Pacific Park. Long Beach was one of a handful of cities to receive a Carnegie grant. The cornerstone was laid on September 5, 1908, and the library opened to the public on May 19, 1909. It remained in use until 1972, when the current library was constructed.

By 1910, Long Beach's population soared to 17,809, earning the city the distinction of being the fastest growing city in the United States. The increase in population was matched by a tripling of the number of square miles within its border, due in no small part to the 1902 opening of the Pacific Electric Railroad, which helped attract thousands of visitors from Los Angeles. The visitors discovered a new pier at Pine Avenue, a saltwater plunge, a 1,800-foot-long pier at Pine Avenue, a Municipal Auditorium, the Walk of a Thousand Lights, and an amusement area later to become the Pike, which included several movie theaters.

Music has been an important part of Long Beach life from its earliest days, when the Cuthbert Family Band played at the Methodist Chautauqua program in the late 1880s. In 1909, the Long

Beach Municipal Band was organized, and local and national newspapers acknowledged that the city was the only municipality supporting a band that played every day. Municipal Band concerts were held on the beach strand and at several parks, not to mention at every public event sponsored by the city. In 1923, the city hired John Philip Sousa's assistant director, Herbert Clarke, to conduct the Municipal Band. Clarke remained until 1943.

On the commercial side, Long Beach assisted in the efforts for San Pedro to become the federal harbor over its rival Santa Monica and lobbied for the construction of a breakwater that would buffer against the waves that battered the shore and caused massive destruction. In 1907, the Los Angeles Dock and Terminal Company dredged for a harbor, and the Craig Shipbuilding Company relocated to Long Beach from Toledo, Ohio, subsequently building 17 ships for the US government by World War I. Numerous industries also sprung up at the port, such as the following: fishing canneries, potash processors, and steel. Two power plants were constructed.

In 1903, Long Beach began its long-term relationship with the US military, especially the Navy, when Pacific Squadron ships anchored off the city. The Big Four Squadron of the 1st Division of the Pacific Fleet returned in 1907. A year later, the 16 battleships of the Great White Fleet (Atlantic Fleet, 2nd Division) were sent by Pres. Theodore Roosevelt around the world and stopped by Long Beach. The sailors were feted to a barbecue by over 50,000 residents, who lined up on the beach to watch the ships sail in. By 1919, Long Beach was known as "home port of the Battle Fleet."

The long stretch of flat, hard sand at the frontage of Long Beach proved to be ideal as a site for early aviators to take off and land. Aviation grew in Long Beach as resident and early aviator Earl Daugherty established the first inland airfield in Long Beach in 1919. Daugherty was instrumental in developing the city's municipal airport, which still bears his name, in 1923. By 1927, Long Beach was home to its first airplane manufacturer, the International Aircraft Corporation.

Daugherty's friend Calbraith "Cal" Perry Rodgers completed the first transcontinental flight by landing in the water near the Pine Avenue pier. The completion of the first transcontinental flight on December 10, 1911, is considered to be one of the most significant events in aviation history. Rodger's plane, the *Vin Fiz Flyer*, is displayed in the Smithsonian National Air and Space Museum in Washington, DC.

Long Beach continued to play an important role in aviation and produced numerous famous aviators in the early 1900s, such as Amelia Earhart, Frank Hawks, Gladys O'Donnell, John Montijo, and Frank Stites.

During and after the Civil War, many moneyed people relocated to the Long Beach area because they were attracted to the mild climate and the potential to acquire real estate inexpensively. Consequently, numerous Long Beach notables served or had relatives who served in the Union (and some in the Confederate) army. In fact, Long Beach had so many veterans that its Great Army of the Republic (GAR) Post 181 was the second largest in the United States. GAR Post 181 was instrumental in the erection of the statue of Abraham Lincoln in 1915 and the renaming of Pacific Park to Lincoln Park, where the statue remains.

Perhaps nothing changed Long Beach more than the discovery of oil at Signal Hill in 1921. Oil brought unimagined wealth to the city and exploded its population from 55,593 to 142,032 in the 10 years that followed. The city literally went on a spending spree, constructing buildings, schools, a Navy landing, Marine Stadium, a police substation in Belmont Shore, a municipal auditorium and Rainbow Pier, and the Second Street bridge. By 1923, the city annexed Alamitos Bay and Naples, expanding to the north side with the annexation of 12 miles of Virginia City. The city purchased land for an airport, completed a landfill for Pier A, and hosted the 1928 Pacific Southwest Exposition, which attracted over one million visitors. The opening of the Ford automobile plant and the Proctor and Gamble soap-making factory added to the prosperity of the city.

Fifty-two people were killed in Long Beach and many others injured when the 6.3 earthquake struck the city on March 16, 1933. The city suffered considerable damage to its buildings but none more severe than the almost complete destruction of all of the schools. For two years, Long

Beach students attended classes in tents or under the bleachers in Recreation Park or in other parks until the new buildings were finished.

By the 1930s, Long Beach had over 145,000 residents and a thriving municipal harbor and airport, city-owned gas and water systems, 448.28 acres of parks, a main library and six branches, 34 schools and a junior college, 65 churches, 12 banks, three transcontinental railroads connecting with the harbor, and one electric interurban railway and three automobile bus lines providing transportation in the city. Oil production since the discovery had soared to over 225 million barrels, continuing to bring revenue to the city and sparing its residents from the full impact of the Depression.

In 1930, the first traffic circle in Los Angeles County was constructed with state and county funds at the intersection of State Street and Hathaway Drive, and it is still in place at what is now Pacific Coast Highway and Lakewood Boulevard. It was built to accommodate the expected traffic from the 1932 Olympics, held in Los Angeles and at the Long Beach Marine Stadium.

Another first for Long Beach came in 1934, when Frank F. Merriam became the first Long Beach resident to be elected governor of the state, having also served as lieutenant governor and in the assembly and state senate. Merriam, the Republican candidate, engaged (with the help of oil, real estate, newspaper owners, and movie producers) in one of the most vicious political campaigns of its time against author and muckraker Upton Sinclair.

Because of its size and location, airport and harbor infrastructure, and vocational training programs and available workforce, Long Beach became the home of the Douglas Aircraft by the end of the 1930s, positioning the seaside city for its next adventures.

One

EARLY INHABITANTS AND SETTLERS

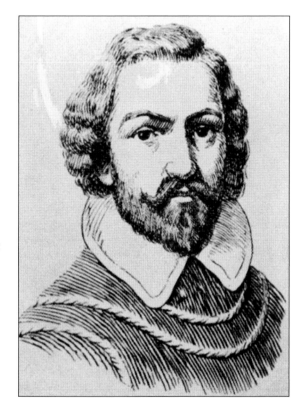

BEFORE LONG BEACH. Spanish explorer Juan Rodriguez Cabrillo and his men most likely saw the fires of the Tongva people in 1542 when they sailed into the bay overlooking the land that would become Long Beach. The fires, set as a way to drive rabbits from the tall grasses, created smoke that could be seen for miles. This prompted Cabrillo to name the bay *Bahia de los Fumos* (Bay of Smokes).

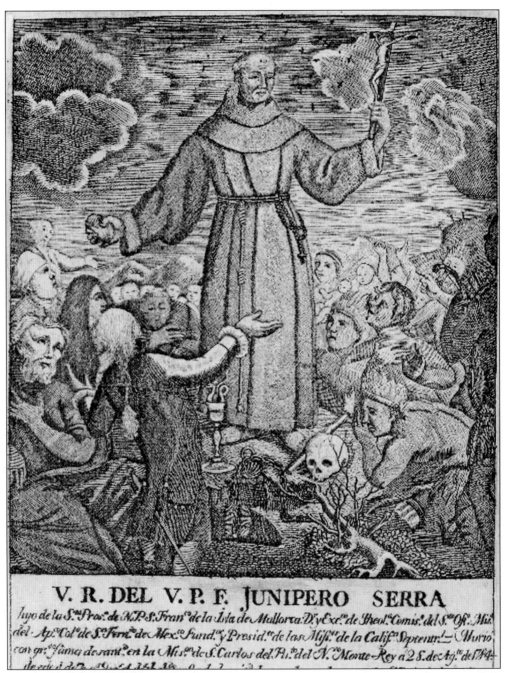

V. R. DEL V. P. F. JUNIPERO SERRA

FATHER JUNIPERO SERRA. In 1602, Spanish explorer Sebastian Viscaino was sent to confirm Cabrillo's findings. Years later, Spain would use the assistance of the Roman Catholic Jesuit and Franciscan priests to colonize the territory known as Alta California, which would become the state of California. Fr. Junipero Serra, depicted in this 1787 lithograph, established a number of missions with the intent of converting and civilizing the native population. Serra took up the cause of the Indians and argued for the removal of Pedro Fages Belata as governor of Alta California in 1774. (Library of Congress.)

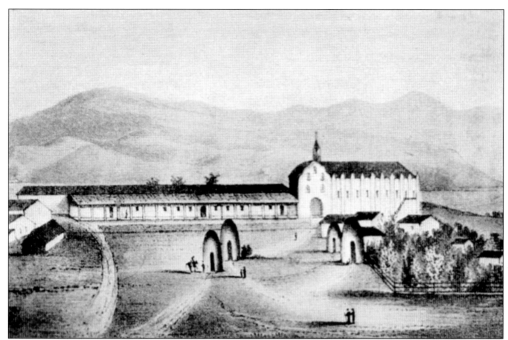

MISSION SAN GABRIEL. Father Serra established the Mission San Gabriel Arcángel on September 8, 1771, the fourth of 21 missions built. Although more than 5,000 Indians who lived in area referred to themselves as Tongva (which in their language means "people of the earth"), the Spanish named them Gabrielinos after the mission, which is pictured above in a 1913 drawing and below in a 1899 photograph. Indian *kiches* constructed of tule grass and willow branches are shown in the front of the mission. The kiches served as dwellings for the Indians who worked at the mission. By the late 1700s, the Tongva were forced by the Spanish to work the land and tend cattle and sheep on the acreage around the mission. (Both, Library of Congress.)

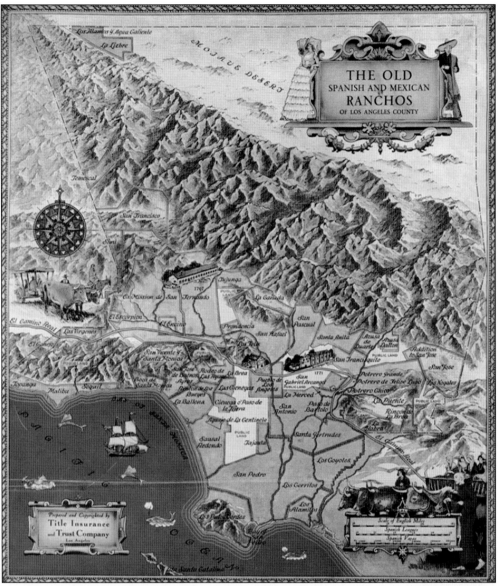

RANCHO LOS NIETOS. Pedro Fages Baleta returned in 1782 to again become governor of Los Californios, and he began giving land to soldiers assigned to the missions for cattle raising. He granted Jose Manuel Nieto, a corporal at Mission San Gabriel, 300,000 acres. The grant included all the land between the Santa Ana and San Gabriel (now Los Angeles) Rivers from the sea to the hill land on the north. The grant was later reduced to 167,000 acres when the priests at the mission claimed the land grant infringed upon the mission. Nieto died in 1814. His land was divided in 1834 into the following five ranchos: Los Coyotes, Los Cerritos, Los Alamitos, San Gertrudes, and Los Bolsas, as shown in this 1919 map prepared by the Title Insurance and Trust Company. Ranchos Los Cerritos and Los Alamitos would eventually become Long Beach. Alamitos Avenue marks the dividing line between the two ranchos. (USC Libraries Special Collection.)

14

Don Abel Stearns. Rancho Los Alamitos (ranch of the cottonwoods) was briefly owned by Gov. Francisco Figueroa and then purchased by Abel Stearns. Born in Massachusetts, Stearns eventually migrated to Mexico and became a naturalized citizen, converting to Catholicism, which qualified him to own land. Stearns married Arcadia Bandini, the 14-year-old daughter of Juan Bandini. In addition to making Rancho Los Alamitos the largest cattle ranch in the United States, Stearns prospered by driving cattle to Northern California for the thousands of people who had come for the Gold Rush. This portrait of Stearns, which was drawn between the years 1840 to 1860, does not show the horrible scars he received in an attack by a drunken customer in his mercantile store. (Rancho Los Alamitos.)

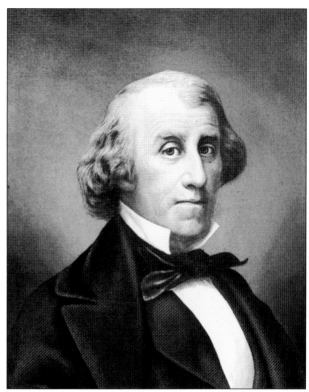

Don Juan Temple. After the death of Doña Manuela Nieto de Cota, the 27,000-acre Rancho Los Cerritos (ranch of the little hills) was sold for $3,000 to Jonathan Temple, who was married to the granddaughter of Manuel Nieto. Temple was a businessman who, like Stearns, became a Mexican citizen and Roman Catholic. Temple and Stearns both used their ranchos for cattle raising until the 1860s, when a drought devastated both the cattle and the value of the lands.

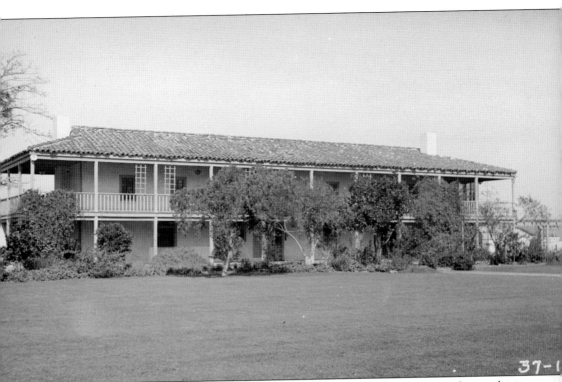

CASA DE LOS CERRITOS. Temple constructed a Monterey-style adobe hacienda on the rancho in 1844. The walls were made of thick adobe, and the roof was made of redwood planks covered by tar from the La Brea Tar Pits. The patio walks were made from brick that had been shipped from New England. In 1866, he sold the rancho to Flint, Bixby & Company, comprised of Dr. Thomas Flint, his brother Benjamin Flint, and cousin Llewellyn Bixby. Jotham Bixby was hired as manager and later acquired an interest in the property. Cousin John W. Bixby relocated from Maine to help with the ranch, which was used to raise sheep. The hacienda was restored in 1930 by Llewellyn Bixby, who used it as his home as it is shown in the 1934 photograph. (Library of Congress.)

FATHER OF LONG BEACH. Jotham Bixby came from Maine to California to find gold. He utilized the land he purchased to raise cattle, and later on, he invested in a flock of sheep that would prove valuable on the Rancho Los Cerritos. In 1879, Bixby began selling areas of the rancho for settlement to Civil War veterans and others who were in search of farming land. His first sales were near the colony of Downey and then to the Wilmington colony. In 1884, he sold 6,000 acres to the California Cooperative Colony. In 1881, he leased 5,300 acres to William E. Willmore, who later created the American Colony Tract, which eventually became Long Beach. Bixby was affectionately referred to as "the father of Long Beach." He died in 1917.

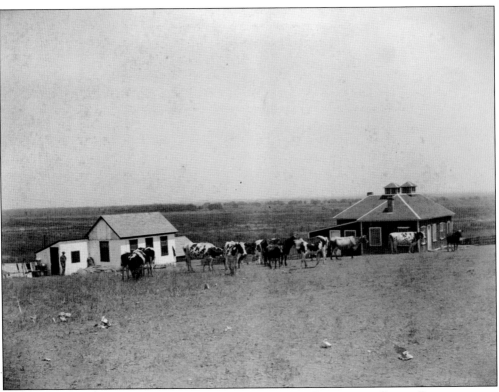

CATTLE AND SUGAR BEETS.
John Bixby not only introduced Holstein-Fresian cattle into Southern California, he also successfully cultivated cattle to local ranches with his prized Los Alamitos Prince, which was noted in the 1887 edition of the *Cultivator and Gentleman* journal. Bixby's cattle were also used for beef, hides, and milk, which was further processed at the Bixby cheese factory. The Bixby family also owned the Los Alamitos Sugar Company and sold tracts of land for growing sugar beets. (Both, Rancho Los Alamitos.)

MARGARET HATHAWAY BIXBY. The wife of Jotham Bixby made considerable contributions in her own right to the development of early Long Beach. The daughter of a Civil War chaplain, Margaret was instrumental in founding the First Congregational Church with her husband. The church remains at Third Street and Cedar Avenue. The mother of seven, she later found time to become involved in fundraising for the Long Beach Day Nursery, the Young Women's Christian Association, and Community Hospital.

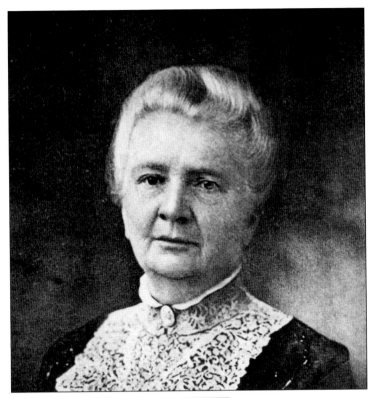

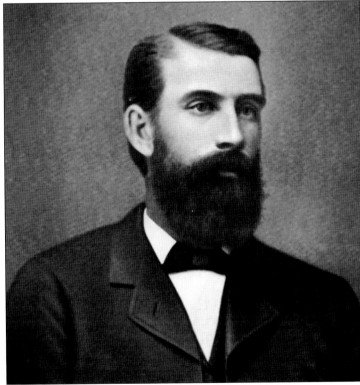

JOHN W. BIXBY. In 1878, John W. Bixby purchased Rancho Los Alamitos from Michael Reese, who had foreclosed on Stearns for failing to pay his mortgage. Bixby formed a company (Alamitos Land Company) with I.W. Hellman and J. Bixby & Company in order to own and manage the rancho. Bixby played a major role in building the area's first school. He also planned the town of Alamitos Beach and chose the Spanish names of the streets still in use. One of his greatest gifts to Long Beach is Bixby Park on Ocean Avenue.

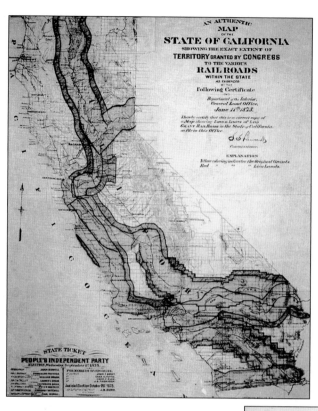

RAILROAD LANDLORDS. Shortly after the Civil War, federal law gave the railroads thousands of "alternate, odd-numbered sections per mile on each side of the road" in order to encourage the expansion of the railroad system across the United States. The railroads embarked upon an aggressive campaign to bring settlers and potential buyers for their properties. This Library of Congress map of 1875 shows the lands granted to the railroads in California. (Library of Congress.)

CALIFORNIA IMMIGRANT UNION. The owners of the railroads wanted to stop the flow of Chinese into California after they no longer needed their labor. In 1869, the railroads established the California Immigrant Union (CIU) in San Francisco with the state purpose of recruiting immigrants who would protect the "homogeneity of our people and perpetuate our system of political liberty." The CIU provided real estate sales to landowners who subscribed to their services. Jotham Bixby was a member of the CIU founding board of directors.

CALIFORNIA IMMIGRANT UNION,

[ORGANIZED OCTOBER, 1869]

FOR THE PURPOSE OF

ENCOURAGING IMMIGRATION

TO THE

STATE OF CALIFORNIA.

PRINCIPAL OFFICE:
534 CALIFORNIA STREET, SAN FRANCISCO.

IMMIGRANTS and others desiring reliable information in reference to PUBLIC OR PRIVATE LANDS IN CALIFORNIA and the mode of acquiring them, can address their communications to the MANAGER OR GENERAL AGENT, or apply at the

CENTRAL OFFICE, 534 CALIFORNIA STREET, SAN FRANCISCO.

Information can be obtained of the best quality of Farming Lands, in the valleys and foothills, at prices varying from

$1.50, $2, $2.50, $3 and $5 per Acre and upwards—

On liberal terms—one, two, three, four and five years' credit.

The "UNION" takes particular care to inform applicants in regard to Government lands and lands belonging to railroad companies.

The "UNION" is prepared to make the most desirable arrangements for the settlement of colonies from the States east of the Rocky Mountains and from European countries, and to obtain cheap transportation for them direct to California.

Good Farming Lands, in tracts of 5,000 to 50,000 acres, can be obtained at $1.50 to $2.50 per acre, and on liberal terms.

New-comers visiting the different counties of California, in search of farming or other lands for settlement, will be provided with letters to the Agents of the "UNION" or other intelligent residents who are disposed to favor settlers, from whom such precise information as they may need—concerning the quality, values and titles, to property in the locality—may be obtained.

Pamphlets containing reliable information in regard to California sent to any part of the United States or Europe, when ordered.

Parties in California having lands suitable for Immigrants, and wishing them offered, can send description and terms to this office.

Information of all kinds, beneficial to Immigrants, respectfully solicited, and will be carefully given to new comers upon their arrival.

President ..WM. T. COLEMAN.
General Agent ...W. H. MARTIN.
CENTRAL OFFICE - - - - 534 California Street, San Francisco.

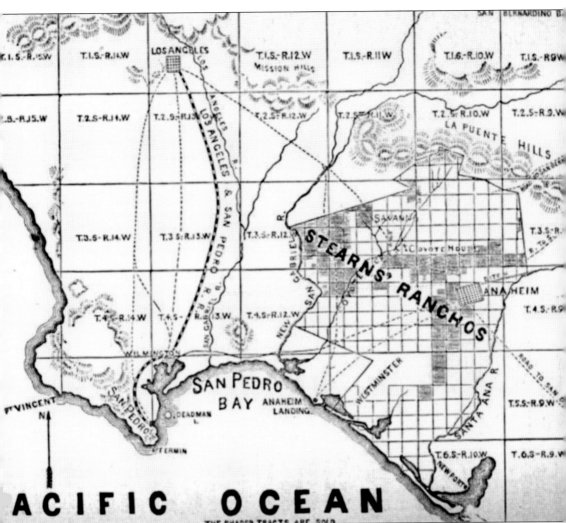

CERRITOS COLONY TRACT. This 1873 map, published by the CIU, advertises available lots on Stearns's ranchos and shows the configuration of San Gabriel and the new San Gabriel River. In 1875, Jotham Bixby sold portions of Rancho Los Cerritos, which created the Cerritos Colony Tract along the Los Angeles River. The settlement was also called the Willows because of the hundreds of trees that sprouted up from the seeds washed on land after the San Gabriel River flooded in 1867. The river also permanently changed its course. The CIU and its later version, the International Colonizing Company, established numerous colonies, including Riverside, Pasadena (also called the Indiana Colony), Lompoc, central California (Fresno), San Jacinto, Penasquitos near San Diego, Ontario, and the American Colony on Rancho Los Cerritos. Settlers were warned not to relocate unless they had $1,000.

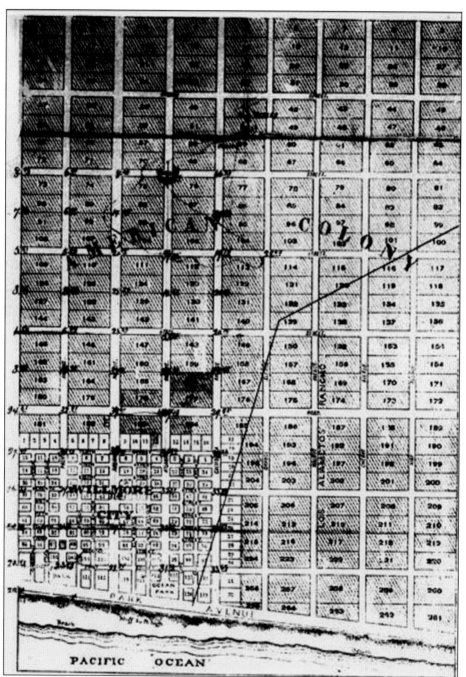

WILLMORE CITY. William Erwin Willmore, an Englishman and teacher, served as the Southern California manager for the CIU. In 1881, Willmore contracted with J. Bixby & Company to develop a farming colony and a town site. The colony would be called the American Colony Tract, and at the urging of a newspaper reporter for the *Los Angeles Daily Star*, the town site within the colony was named Willmore City. Willmore initially planned to utilize 10,000 acres of Rancho Los Cerritos, but the size was reduced by Capt. C.T. Healey, who was hired in 1882 to survey and lay out the tract. (Long Beach Public Library.)

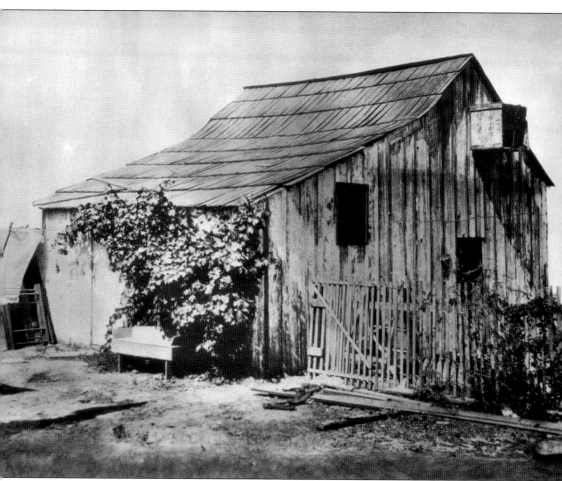

FIRST BUILDING. The California Immigrant Union launched an advertising campaign that targeted 100 newspapers and 35 magazines in the Midwest and East Coast. Advertisements offered 10,000 acres of prime farming land on the "splendid Los Cerritos Rancho" at "low prices and easy terms." Rail excursions were also arranged, but few came and fewer bought the farmland, which until recently had been considered only fit for sheep and cattle. The colony was two miles away from the railroad, near the ocean. Visitors had to hire "private conveyances" from Wilmington in order to view the property. The only building in the area was an 8-by-10-foot shack built in 1879 that stood where First Street and Pine Avenue are located today. It is pictured in this 1880 photograph by C.J. Daugherty. Prospective buyers had nowhere to stay during their visit. In a short time, the CIU withdrew its support of the project.

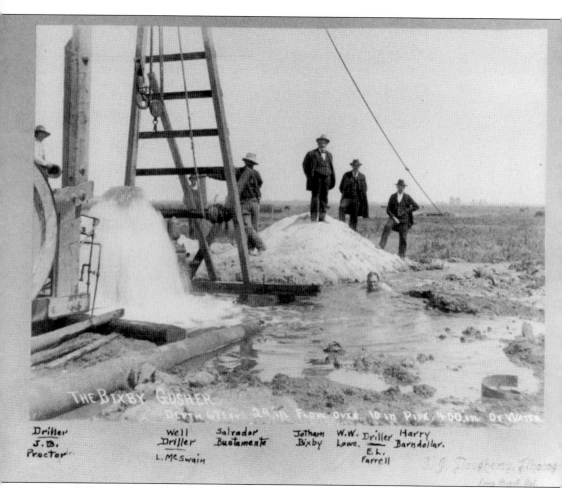

THE BIXBY GUSHER

Driller
J. B.
Proctor

Well
Driller
L. McSwain

Salvador
Bustamente

Jotham
Bixby

W.W.
Lowe.
E. L.
Farrell

Driller

Harry
Barndollar.

BIXBY'S GUSHER. William Erwin Willmore and several others formed the American Colony Land and Water and Town Association, setting out to sell land at $50 an acre with $10 of it to be placed into a fund for providing water and planting trees. Willmore served as secretary of the association. Ample sources of fresh water were needed for the new colony and farming areas. A spring ran through the ranchos, and underneath the ground were numerous artesian wells that would provide water for the area. In 1881, Bixby drilled for three artesian wells, which produced water described in early publications as having a "yellowish tinge and slight flavor" that was "delightfully soft for washing." The abundance of artesian wells would be very beneficial to the growth of Long Beach. (Rancho Los Alamitos Collection.)

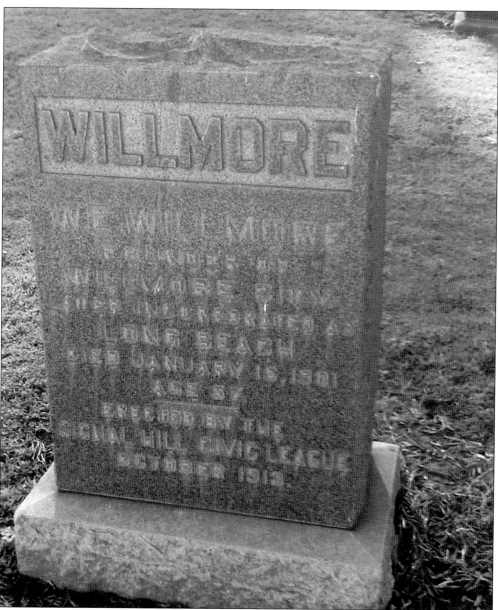

A Dying Dream. Despite William Erwin Willmore's enthusiasm, by 1884, only a dozen small houses were built and a few tracts of land sold. A small bathhouse stood on the beach near Pine Avenue, and the Bay View Hotel was open. Willmore could not pay his option contract, and in May 1884, he relinquished his rights to the land. The colony and town he had envisioned with farms, homes, a business district, parks, and a college would eventually be developed. Willmore never saw his dream realized. He moved to Arizona and suffered from heat stroke. Returning to Long Beach, he was committed to the County Farm, where he died in 1901. He is buried in the Municipal/Sunnyside Cemetery in Long Beach, California, where a graveside marker was placed in 1913 by the Signal Hill Civic League. A portion of the downtown area in Long Beach has been designated the Willmore City Historical District.

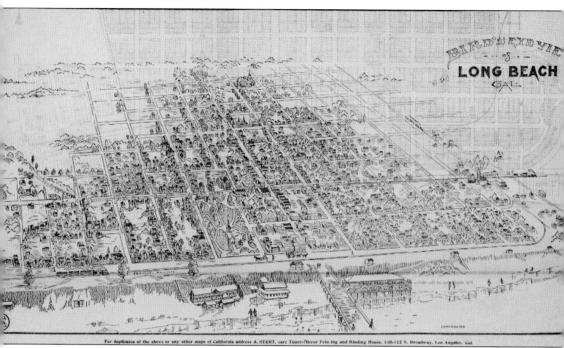

LAYING OUT A CITY. Charles Terraine Healey, the organizer and captain of the home guard in San Jose during the Civil War, was also the first licensed surveyor in California. He did extensive surveying of almost every Spanish land grant south of San Jose, including the Bixbys' land that became the American Colony Tract, Willmore City, and then Long Beach. Healey's wife, Orlena Medora, was the recording secretary of the Long Beach Women's Christian Temperance Union (WCTU) and a founder of the Ebell Club. Healey later served as Long Beach city engineer.

Two

THE LONG BEACH

RAILROAD FARE WAR. The railroads initiated a rate war in the spring of 1886, offering fares from the Missouri River to Los Angeles for $1 to $15. At the same time, through their organizing colonies, the railroads marketed land to residents of Iowa and Nebraska, who did well buying railroad land in their own states and also came west in large numbers to purchase land in California. (Library of Congress.)

THE CITY OF LONG BEACH. Weeks after William Erwin Willmore relinquished his contract, the real estate firm of Pomeroy and Mills purchased Willmore City and the American Colony Tract for $240,000 from Bixby. An additional $8,000 was paid to Willmore for the water system and other improvements he made. A syndicate was formed to develop the property, and its members agreed that a new name was needed. After several ballots and the lobbying of Belle Lowe (at left), Willmore City was renamed to reflect the area's greatest asset: a long beach. The real estate syndicate incorporated as the Long Beach Land and Water Company. Lowe's husband, William (below), was appointed by Pres. Grover Cleveland as the city's first postmaster, operating a post office out of his mercantile shop at 18 Pine Avenue. Belle Lowe was instrumental in establishing the first school in the area.

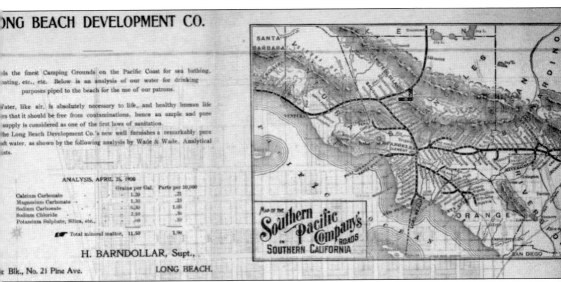
LONG BEACH LAND DEVELOPMENT COMPANY. William Erwin Willmore's dream was no fantasy to real estate developers. They too saw the value in the fertile soil and artesian wells of the area and the potential for commercial, residential, and business development. The completion of the third transcontinental railroad in 1897 to the Los Angeles area brought additional tourists and buyers for the lots. The Long Beach Land Development Company promoted the area as shown in the above advertisement, focusing upon the water supply of "remarkably pure and soft water." H. Barndollar, superintendent of the land development company, later served as president of the city council and as the city treasurer of Long Beach.

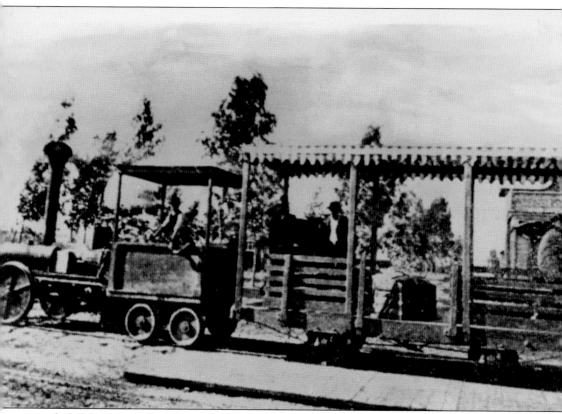

G.O.P.R.R. Judge Robert Maclay Widney, attorney for the American Colony Land, Water, and Town Association, was also an entrepreneur who invented farming tools and transportation systems in Los Angeles and in Willmore City. The American Colony railroad provided three miles of horse-drawn transportation from the railroad depot to the Long Beach Hotel. The railroad (shown above) was referred to in the press as the Get-Out-and-Push Railroad because it often bogged down on redwood rails, requiring male passengers to get out and push the car. By 1889, Long Beach connected directly with San Pedro, Los Angeles, and Rattlesnake Island by the Southern Pacific Railroad and the Salt Lake Terminal Railway. (Long Beach Transit.)

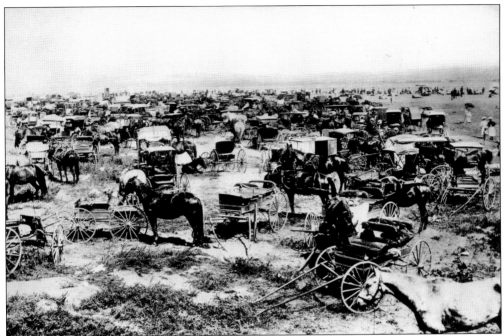

HORSES ON THE BEACH. The long beach also attracted visitors by horse and buggy. Most visitors to the beach usually stayed fully clothed when they visited. Later, bathing suits became popular. Horseback parties and racing along the beach and between the two ranchos were also activities in the 1800s. The area was home to wild horses that grazed on the open pastures. (Long Beach Public Library.)

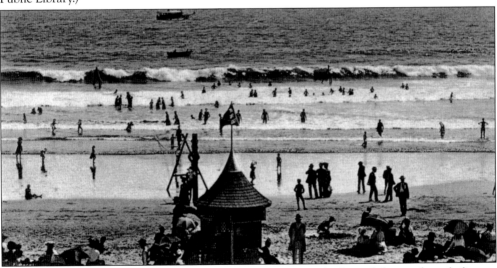

BATHERS IN THE SURF. This 1904 photograph shows visitors who braved the rough surf adjacent to the Pine Avenue pier. The waves and breakers were forceful, and often newspapers carried stories of mothers losing their small children, who were swept out to sea. One news account told of a mother whose two-year-old was swept out to sea from a chair in the sand that was next to a cottage the family was renting in a tent city on the strand. A towline was installed so that bathers could hold on while they enjoyed their time in the ocean. A lifeguard station can be seen with the flag atop.

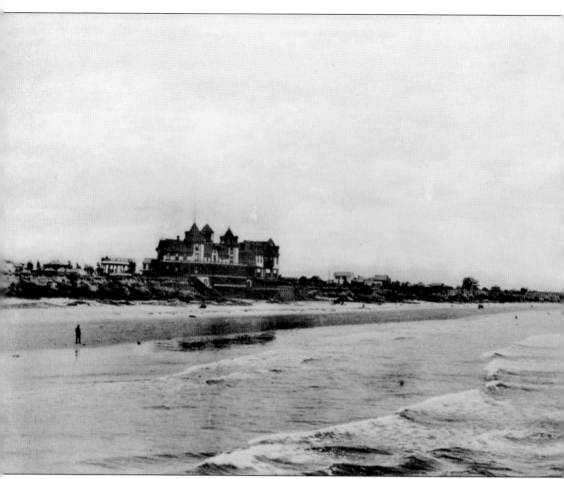

LONG BEACH HOTEL. The Long Beach Hotel was built in 1884 on the bluff across from Pacific Park. The five-story building included three stories on the sand and a public bathhouse. Built for $50,000, it featured the latest conveniences for tourists, such as speaking tubes, steam heat, and a large dining room overlooking the ocean. The expansion of the two railroads to and through Long Beach and their connection with coast steamers in the nearby San Pedro Bay contributed greatly to bringing visitors to the new city. The hotel caught fire in November 1888, just as the real estate market was crashing. The destruction of Long Beach's finest and only hotel was devastating to its citizens and its economy. (Long Beach Public Library.)

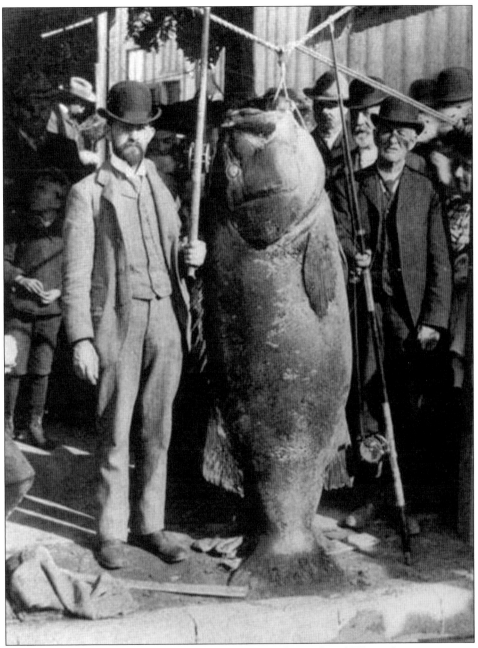

PLEASURE PIER AND FISHING. In 1885, the Long Beach Land and Water Company received permission from Los Angeles County to build a pleasure pier and wharf at the foot of Magnolia Avenue for fishing and boating. The voters approved a $4,000 construction bond. The pier was 700 feet in length and 35 feet in width. Band concerts were provided in the summer. A light was installed underwater for night fishing. Newspapers throughout the United States reported on the variety of ocean fishes that could be caught off the pier in Long Beach. Shown in the photograph is a 632-pound fish caught by William Schilling and his son. Schilling operated a general store in Long Beach. Fierce waves destroyed the pier and carried parts of it out to sea in 1900. (Long Beach Public Library.)

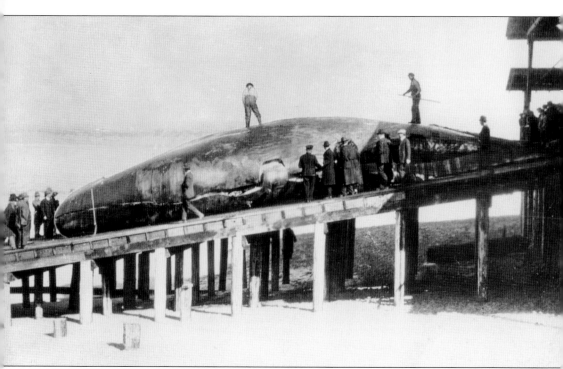

MINNIE THE WHALE. On May 20, 1887, a large finback whale nicknamed as Minnie washed up on shore near Alamitos Avenue. A group of young men roped the whale and then killed it with wooden stakes. The Union Pacific Railroad and the City of Long Beach jointly spent $5,600 to purchase the carcass from the men, thinking it would be a great tourist attraction. It took 40 men to remove the whale's skin and head. The 65-foot skeleton was preserved and the bones shellacked and placed on display in Pacific Park until 1907, when the bones were moved to Colorado Lagoon to make way for a new library. In 1933, the remains again were removed to an old firehouse at 339 Pacific Avenue. The remains were eventually given to the USC Museum of Natural History, because it lacked a finback whale skeleton in its collection.

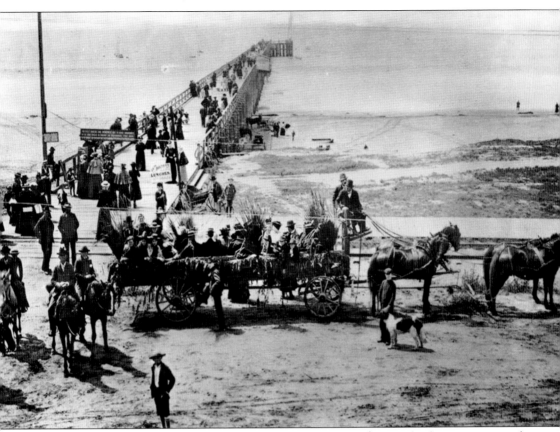

PINE AVENUE PIER. In 1892, a bond election was conducted to raise $15,000 for the construction of a municipal pier at Pine Avenue. The single-deck pier was promoted as necessary to accommodate oceangoing steam ships and fishing and pleasure boats. Work was completed on May 27, 1893, and the Southern Pacific Railroad ran a midnight train so that visitors could join in the festivities and a public barbecue of sheep and beef from the local ranchos. Almost immediately, the wooden pier was battered by waves and seriously damaged. Because state law would not allow the city to spend money on a dance hall pavilion, the city called the structure it built in 1899 on the east side of Pine Avenue pier a bathhouse. The building included several changing rooms so that the city could justify the expenditure.

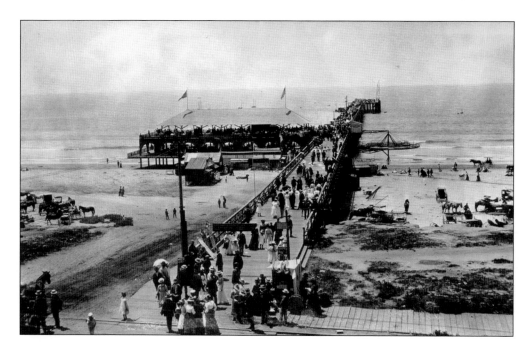

PIER DAY. A $100,000 bond was passed in 1903 for the construction of a new 1,000-foot-long, 32-foot wide, double-decked concrete pier at Pine Avenue (above). The pier was officially opened during Pier Day on November 12, 1904, by Gov. George Pardee, who was given the key to the city by Miss Ella Wilson, Queen of the Sea. The celebration included a barbecue, banquet, yacht races, football games, and a band concert. The adjacent pavilion caught fire on January 5, 1905, and residents rushed to approve $30,000 in bonds for the construction of an auditorium on the site of the pavilion. The new auditorium opened on November 15, 1905, and provided 40,000 square feet of space for public gatherings, including a picnic deck. The pier and pavilion were painted red, white, and green.

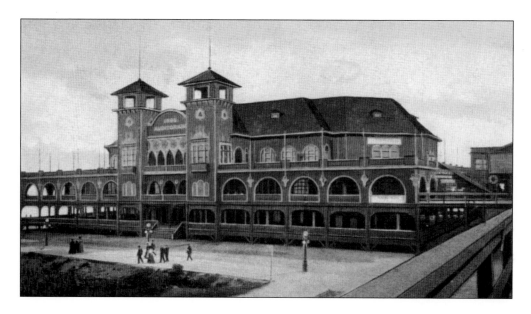

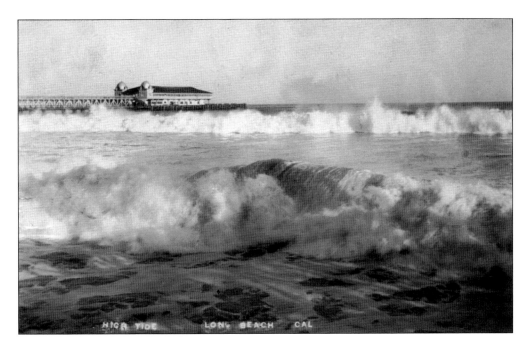

SUN PARLOR. A sun parlor enclosed in glass was built at the end of the pier in 1906 and gave visitors breath-taking views of crashing waves while they read books, attended state picnics, or danced. The floor measured 60 by 180 feet and could accommodate 600 people. April 6, 1906, was declared Sun Parlor Day, and local residents participated in the festivities. In the 1920s, the city operated the Service Men's Club in the sun parlor. During the 1911 transcontinental flight by Cal Rodgers, the sun parlor served as the place where his aeroplane was taken for repairs after he crashed in Compton. Photographs and postcards show the continued high waves that battered the pier, eventually destroying the caissons and piles.

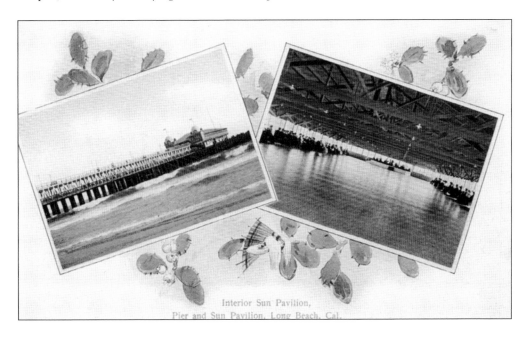

Interior Sun Pavilion,
Pier and Sun Pavilion, Long Beach, Cal.

Bluefield Daily Telegraph

10 Pages Today — Volume XII. No. 125. — Bluefield, W. Va., Sunday Morning May 25, 1913.

THIRTY-THREE DEAD, MANY INJURED IN COLLAPSE OF PIER

Victims of Appalling Accident at Long Beach, Cal., Were Mostly Women.

HUNDREDS DASHED ONTO TOPS OF OTHER HUNDREDS

Two Weeks to Uphold Burden of Nearly Ten Thousand Human Beings Assembled for Festivities of British Empire Day Land End of Big Double Deck Structure Crumbled.

LETTER COMES FROM FIANCEE OF LATE W. F. DANKS

Miss Winifred Green Makes Numerous Inquiries Concerning Mysterious Death.

HAD BEEN BETROTHED FOR A DOZEN YEARS

MONUMENT MAY BE ERECTED IN COURT HOUSE SQUARE

Matter Discussed at Meeting of Confederate Veterans at Princeton.

DELEGATES CHOSEN TO CHATTANOOGA REUNION

ROYAL HAS

EMPIRE DAY TRAGEDY. From the moment it was built, severe storms with 15-to-20-foot swells pounded the pier and sun parlor, damaging the pilings and dislodging boards on the lower decks. Oil was sprayed on the waves to lessen their impact on the pier but the structure was weakened and unsafe. On May 24, 1913, thousands gathered on the pier and in the auditorium to celebrate British Empire Day in honor of the anniversary of the birthday of Queen Victoria. Crowds lined up in front of the auditorium. Following a parade, a section of the flooring suddenly collapsed, sending 350 women, men, and children to the sand below. The final toll was 36 crushed to death and 174 injured. Most the victims were women. The catastrophe was covered in almost every national and local newspaper, as can be seen in the sampling of headlines from Galveston, Texas (below), and Bluefield, West Virginia (above). The city was sued for the faulty construction of the pier and the weakened pilings. In 1915, the auditorium was repaired and reopened. A 1919 earthquake produced high swells and washed out a great portion of the pier. By 1934, rough seas demolished what was left of the pier.

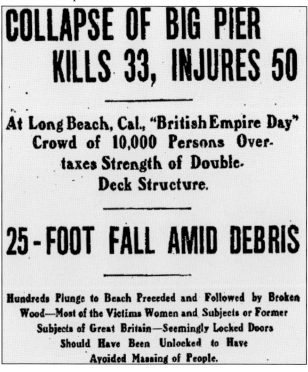

COLLAPSE OF BIG PIER KILLS 33, INJURES 50

At Long Beach, Cal., "British Empire Day" Crowd of 10,000 Persons Over-taxes Strength of Double-Deck Structure.

25-FOOT FALL AMID DEBRIS

Hundreds Plunge to Beach Preceded and Followed by Broken Wood—Most of the Victims Women and Subjects or Former Subjects of Great Britain—Seemingly Locked Doors Should Have Been Unlocked to Have Avoided Massing of People.

COL. CHARLES R. DRAKE. Charles Rivers Drake, a descendant of Sir Francis Drake, was born in Walnut Prairie, Illinois, on July 26, 1843. Drake served both in the Navy and the Army and was assigned to Fort Lowell in Tucson, Arizona Territory. Leaving the Army in 1875, Drake became involved in territorial government, real estate, and a business that provided labor and provisions for the Southern Pacific Railroad. In 1900, he moved to Long Beach, where he purchased beachfront property and became president of the Long Beach Bath House and Amusement Company and the developer of the Bixby Hotel and the luxurious Hotel Virginia.

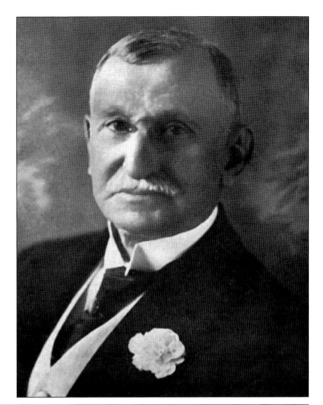

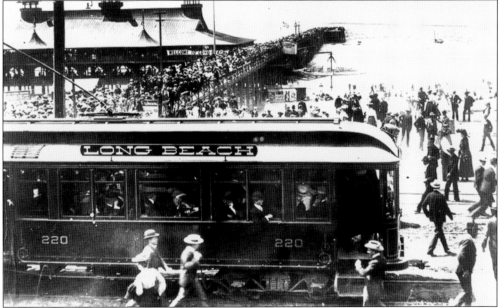

JULY 4, 1902. Charles Rivers Drake brokered a franchise on behalf of Henry E. Huntington to build the Pacific Electric Railway, also known as the Red Car system, from Los Angeles to the corner of Ocean Park and Pacific Avenues. Huntington invested $100,000 for the rail line and the bathhouse. More than 60,000 people came to Long Beach for the Fourth of July opening of the trolley and the bathhouse, as shown in the photograph from Long Beach Transit.

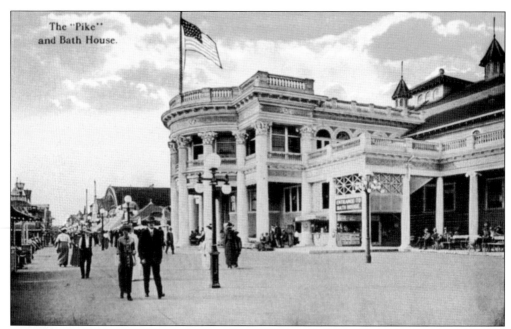

The "Pike" and Bath House.

BATHHOUSE AND PLUNGE. The bathhouse was wildly popular because it was the only one in the area. It was located along a strip of beach called the Pike, which provided the beginnings for an amusement location that would expand to a band pavilion and the Majestic Skating Rink. The corner part of the bathhouse contained the largest bowling alley on the West Coast. In 1910, an additional bathhouse was constructed with 500 dressing rooms. In 1924, a tiled saltwater plunge opened, taking its salt water from a pipe that ran along the Pine Avenue pier out to the ocean. The water was heated, and ladies and gentlemen were permitted to bathe together. Visitors could watch from balconies on both sides of the pool.

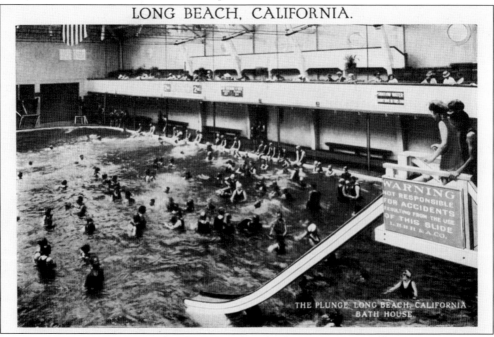

LONG BEACH, CALIFORNIA.

THE PLUNGE, LONG BEACH, CALIFORNIA
BATH HOUSE

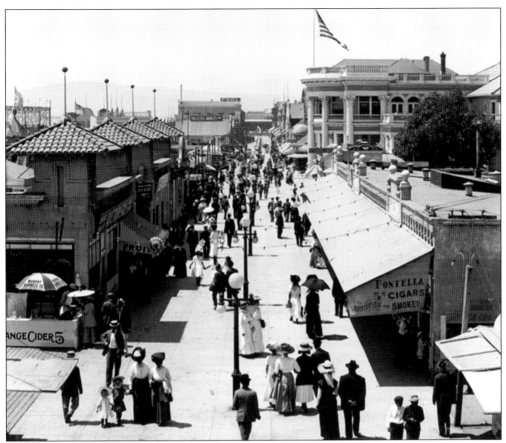

WALK OF A THOUSAND LIGHTS. Thomas Edison's incandescent white and purple lights were still a novelty when they were strung across the boardwalk area, forming the Walk of a Thousand Lights and creating a carnival-like atmosphere. The area was expanded as a miniature Coney Island with games, rides, movie and live theaters, roller coasters, dance halls, a Looff carousel, and other attractions. On the west side of Cedar Way to Chestnut Walk, the Silver Spray pleasure pier was added and extended 600 feet into the water. Eventually, the amusement zone became known as the Pike, and it remained popular throughout the 1950s, being renamed the Nu-Pike. It closed in 1979. (Above, Library of Congress; below, author's collection.)

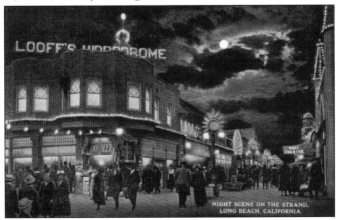

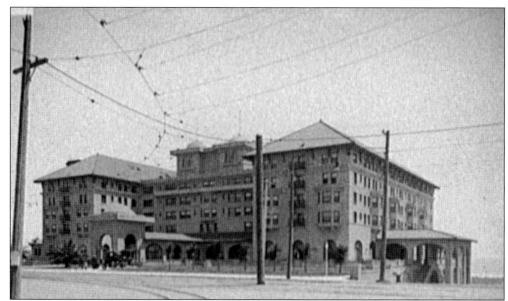

HOTEL VIRGINIA. In July 1906, the cornerstone was laid for a new hotel along the ocean between Chestnut and Magnolia Avenues across from Pacific Park. Hotel Bixby was a development project of Charles Drake and Jotham Bixby. Four months later, several floors of the hotel collapsed, killing two workmen and injuring many others. The Salt Lake Railroad brought a crane to help remove the heavy timbers. After rebuilding, the hotel was renamed Hotel Virginia, as shown in the Library of Congress photograph above. It was considered to be one of the most luxurious hotels in California. The ocean view, lush sunken gardens, flower walk, and tennis courts provided a cosmopolitan elegance. It was advertised nationally as the "showplace of the Southland" and "absolutely fireproof." (Above, Library of Congress; below, author's collection.)

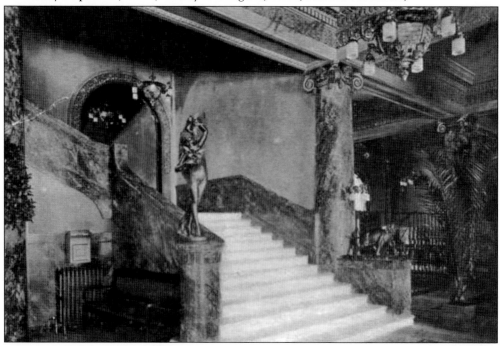

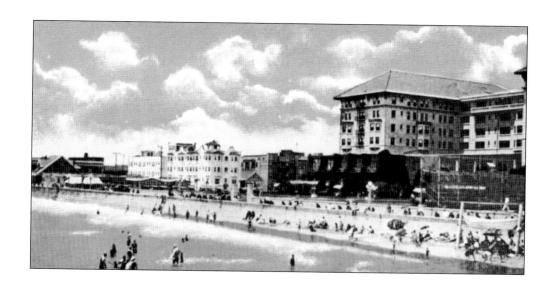

VIRGINIA COUNTRY CLUB. The oceanfront hotel was protected from the battering breakers by a seawall. Gardens surrounded the sides and front. Although a park was across from its entrance, a Virginia Country Club board of directors was formed in 1910 and leased 116 aces east of Long Beach from the Alamitos Land Company. Today, the area is known as Recreation Park. A clubhouse and nine-hole golf course were developed for the guests to use at the Hotel Virginia and country club. In 1921, the Virginia Country Club moved to its current Los Cerritos location. Charles Drake lived in the Hotel Virginia until his death in 1928. The hotel was demolished in 1932.

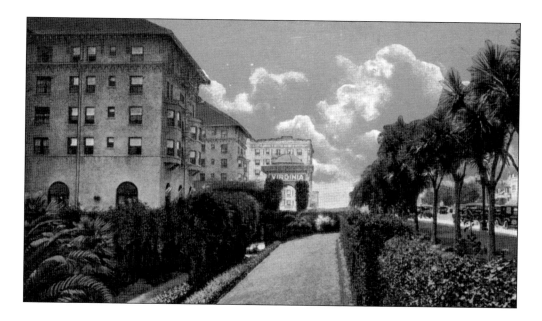

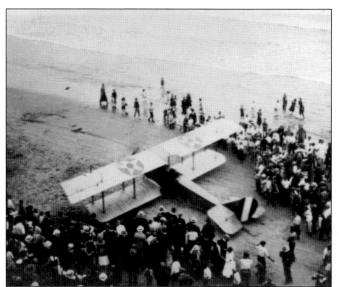

AVIATION ON THE STRAND. The hard, firm sand on the strand along the ocean provided many advantages for Long Beach. As aviation exploded in Southern California in the early 1900s, aviators found the sand an excellent place from which to take off and land. The Hotel Virginia and the Earl Apartments (owned by C.J. Daugherty) provided oceanfront locations from which to build and launch planes made by Long Beach aviator Earl S. Daugherty. (Long Beach Municipal Airport Archives.)

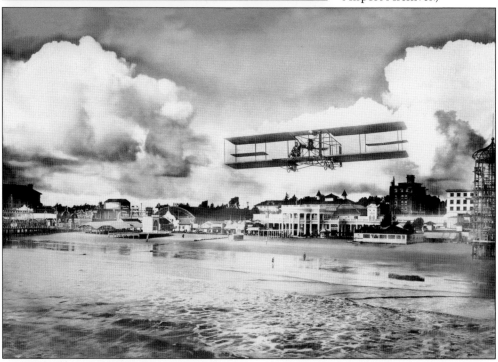

THE FATHER OF THE LONG BEACH AIRPORT. Earl S. Daugherty is pictured flying over the strand in Long Beach. The amusement zone added aviation-themed rides, as can be seen to the right in the photograph with Bisbey's Airship metal tower. Daugherty became a military trainer of pilots in World War I. He opened the city's first inland airfield near American Avenue (now Long Beach Boulevard) and Bixby Road. He later moved to a 23-acre parcel on Willow and American Avenues, where he gave flight lessons and sold airplanes. Daugherty was named one of the first aviation commissioners for the city and advocated for a municipal airport. In 1929, the City of Long Beach named the airport after Daugherty, who perished in a plane crash the year prior. (Long Beach Municipal Airport Archives.)

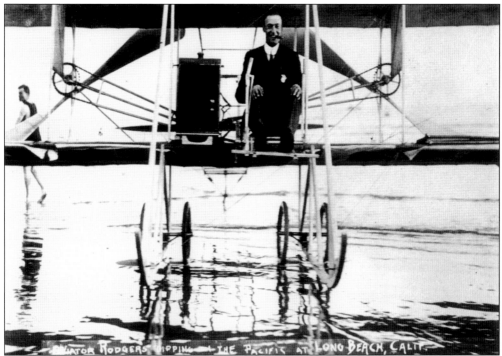

THE FIRST TRANSCONTINENTAL FLIGHT. On December 10, 1911, Cal Rodgers completed the first transcontinental flight from Sheepshead Bay, New York, to Long Beach, California, when he landed in water just near the Pine Avenue pier. Rodgers attempted to complete the flight in 30 days in order to receive a $50,000 prize from William Randolph Hearst but failed because of numerous crashes. Landing in Pasadena, he was approached by the Long Beach Chamber of Commerce and was offered $5,000 to finish his flight in Long Beach. Rodgers took off from Pasadena but crashed in Compton, seriously injuring himself. His plane was taken to the sun parlor at the Pine Avenue pier and repaired. After a brief recuperation, Rodgers flew to Long Beach and was escorted over the water by Daugherty, Frank Champion, and Beryl Williams, other Long Beach aviators. Rodgers's historic flight in 1911 is featured at the Smithsonian National Air and Space Museum in Washington, DC. Rodgers crashed and broke his neck on April 3, 1912, just 100 yards from the Pine Avenue pier. (Both, Library of Congress.)

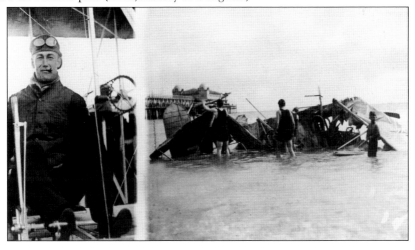

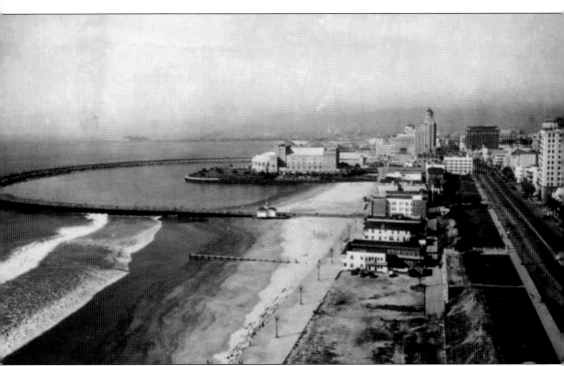

Rainbow Pier and Auditorium. From 1909, city developers discussed building a horseshoe pier that would connect Pine and American Avenues. In 1928, residents approved a $2.8-million bond issue for the construction of both the pier and a 15,000-seat municipal auditorium that was to serve as a convention center. The project required filling in 20 acres of beach area on which the auditorium was built. The pier's name came from Flora Darling, who in 1929 suggested it to the local newspaper after seeing a rainbow in the surf near the proposed site. A lagoon was created that allowed boating and swimming. A road circled the lagoon on which automobiles and bicycles could ride. In 1960, the pier was demolished and the lagoon filled in due to increasing subsidence in the area because of oil drilling. (Long Beach Public Library.)

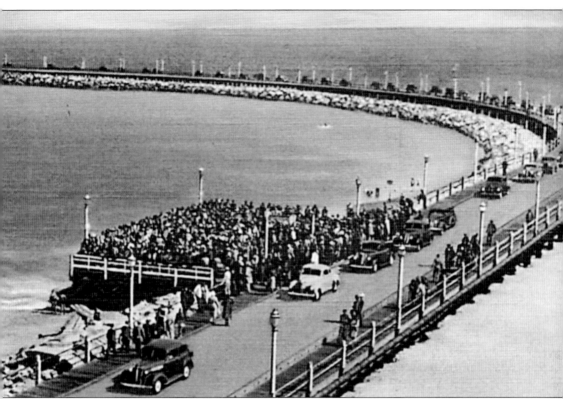

University by the Sea. News accounts indicate that the university by the sea, also known as the "spit and argue club," started near the old Pine Avenue pier when farmers talked about the crops and weather. The group became so large that it was moved to the more spacious east side of the west Rainbow Pier breakwater, where a 3,200-foot platform was constructed for speakers. The City Recreation Commission controlled the site and established rules and regulations for speakers. The public could openly debate any topic for 10 minutes, which often caused a stir when pro-Communist speakers or politicians talked. No profanity or drinking was allowed. Discussions became so rowdy in 1949 that the Long Beach Police sent officer John Logan with his blackjack to dispense some "shillelagh justice" to offenders of the rules.

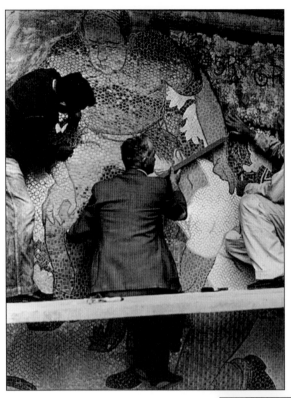

WPA Mosaic Mural. One of the largest Works Progress Administration art mosaic murals in the United States was completed in Long Beach and placed over the entrance to the Municipal Auditorium in 1937. It took 60 artists and 10 months to install, costing $40,000 from the federal government and $3,000 from the City of Long Beach. Designed by Henry Allen Nord and redesigned by Albert Henry King and Stanton MacDonald-Wright, the mosaic portrayed the many aspects of recreation. Weighing 68 tons and measuring 900 square feet, the mosaic was moved from the Municipal Auditorium in 1975 and reinstalled on the downtown promenade in 1982. (Both, National Archives.)

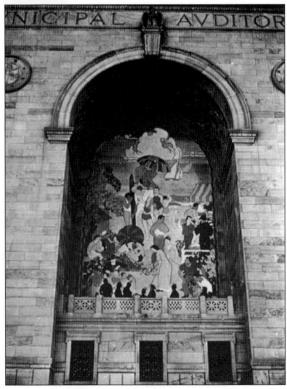

Three

ALAMITOS BEACH TRACT AND BELMONT HEIGHTS

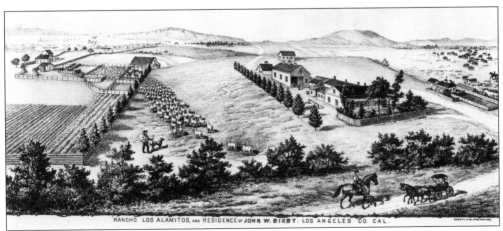

RANCHO LOS ALAMITOS. The City of Long Beach was eventually comprised of portions of the two ranchos, Los Cerritos and Los Alamitos. The eastern portion of the lands contained a natural harbor at Alamitos Bay, the San Gabriel River, artesian wells and springs, and expansive pastures that provided for cattle, sheep, and farming. (Rancho Los Alamitos.)

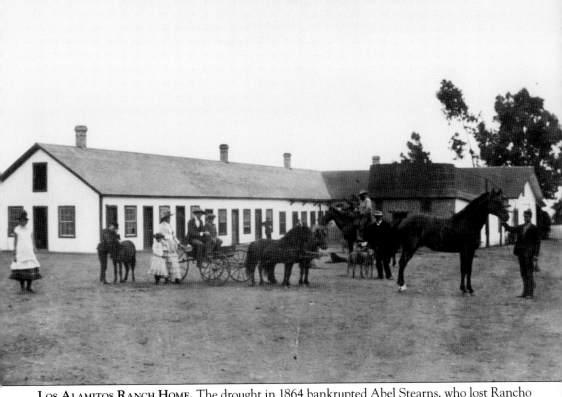

LOS ALAMITOS RANCH HOME. The drought in 1864 bankrupted Abel Stearns, who lost Rancho Los Alamitos to a San Francisco businessman Michael Reese. In 1881, John Bixby purchased the rancho from Reese's estate with J. Bixby & Company and Isaias W. Hellman. After purchase, the living quarters were improved, turning the house into a respectable Victorian home. After John's death, the property was divided. His wife, Susan, remained at the adobe, adding rooms and other improvements until her death in 1906. John's only son, Fred, took over the rancho, going back and forth to the Bixby home at Ocean and Cherry Avenues. (Rancho Los Alamitos.)

LA CASA DE LOS ALAMITOS

LONG BEACH

LOS ANGELES COUNTY

CALIFORNIA

SKETCH MAP
SHOWING LOCATION

ERECTED – ORIGINAL PORTION · ABOUT 1785

HISTORIC AMERICAN BUILDING. In 1906, Fred Bixby and his sweetheart (from the University of California, Berkeley) and wife, Florence, moved into the adobe on the rancho, decorating it in a more modern style that reflected Fred Bixby's interest in the Wild West. In the 1920s, oil was discovered on the rancho. Fred Bixby continued ranching and land development until the mid-1950s. Beginning in 1920, ornate gardens were planted on the grounds of the rancho residence. The rancho and it structures were part of the Historic American Buildings Survey by the Works Progress Administration in 1936, as shown in these drawings at the Library of Congress. In 1968, seven acres of the rancho and the buildings were donated to the City of Long Beach, which maintains the site as a historic landmark. The area was initially inhabited by the Tongva native people, whose ceremonial gathering place, Povuu'nga, was located on what is now known as Bixby Hill. Commercial development of rancho land that was donated for a state university was halted in 1996, when the Gabrielinos/Tongva filed a court action against California State University, Long Beach. (Both, Library of Congress.)

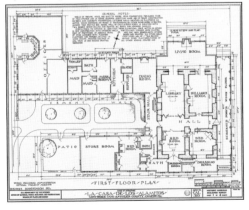

BIG BARN. Phineas Banning, developer of Wilmington and San Pedro, wrote to Pres. Abraham Lincoln suggesting that the pro-Confederacy movement in California needed to be stopped. In 1861, Banning and Benjamin D. "Don Benito" Wilson donated land for the construction of a Union garrison, and Camp Drum was created. It was named after Col. Richard C. Drum, who was the adjutant general of the Army Department of the Pacific. The site housed a supply depot, a training facility, and a telegraph terminal. By 1875, the barracks were no longer needed by the military and were sold back to Banning and Wilson. Wilson donated buildings and 10 acres of the land to the Methodist Church to establish a college, which was named in his honor. The Alamitos Land Company later purchased and dismantled one of the warehouses and moved it to Rancho Los Alamitos, where it was used as a barn. (Rancho Los Alamitos.)

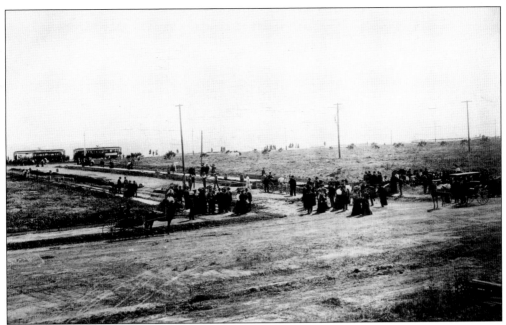

ALAMITOS BEACH TRACT. With the help of surveyor Charles Healey, John Bixby platted out the Alamitos Beach Tract town site, stretching from Alamitos Avenue to Redondo Avenue, with the intent to sell 5- and 10-acre tracts for suburban homes and fruit ranches. John Bixby personally named the streets in the planned 20-block town site. Avenues running north and south were given Spanish names. The early 1900 photographs show the land sales. Bixby died in 1887 and did not see his plans implemented. Following his death, the Alamitos Land Company was formed with the heirs of John Bixby, J. Bixby & Company, and I.W. Hellman in order to expand the development to the east and the north. The land company initiated planning for the development of the natural harbor at Alamitos Bay to compete with San Pedro. (Both, Long Beach Public Library.)

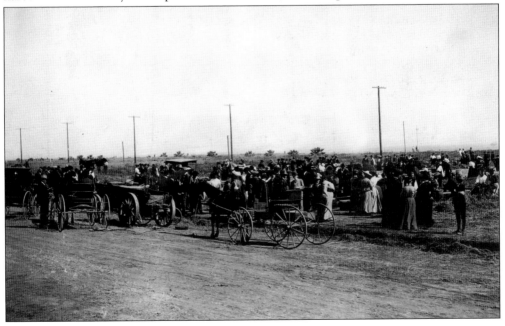

ALAMITOS PARK. Bixby provided a lasting gift to the residents of Long Beach. He planted trees throughout the rancho and developed a park along the oceanside, which was initially named Alamitos Park and then later Bixby Park. Groves of palm trees, eucalyptus, and pepper trees provided shade. Benches and tables were added for picnics. The park also had a goldfish pond with giant water lilies and an aviary with a variety of birds, as well as several cages of monkeys. For many years, Bixby Park was the site of state association picnics, drawing as many as 75,000 natives from the Hawkeye state of Iowa each August. The 1924 photograph below shows the Cripple Creek District (Colorado) picnic held in the park. The park was acquired by the City of Long Beach in 1903, when the area was annexed. (Above, author's collection; below, Long Beach Public Library)

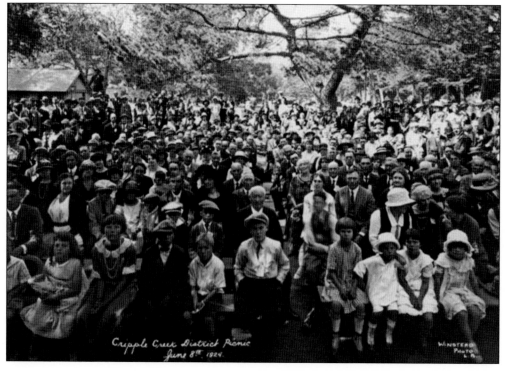

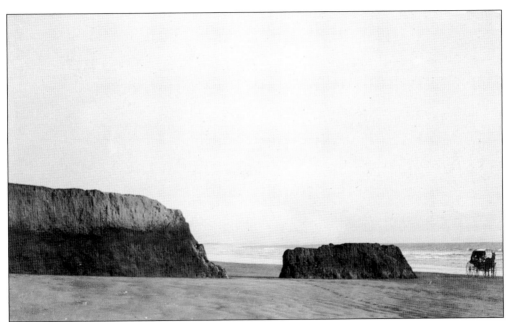

Devil's Gate. The annexation of Belmont Heights City in 1909 by Long Beach came with the promise of a park. However, some of the residents argued for a pier. A bond election in 1910 approved $50,000 for a 1,000-foot concrete pier. However, the court held that the election was illegal because it lacked the two-thirds vote of the residents needed for approval. The city tried in 1913 and in 1914 to pass the pier bond. The pier was opened in 1915 at the foot of Thirty-Ninth Place near Devil's Gate (shown above), which was the name of a large rock off the bluff area. The completed pier was 975 feet long and 112 feet wide, as shown in the 1920s photograph below. The city added a comfort station in 1916. (Above, USC Libraries Special Collection; below, Long Beach Public Library.)

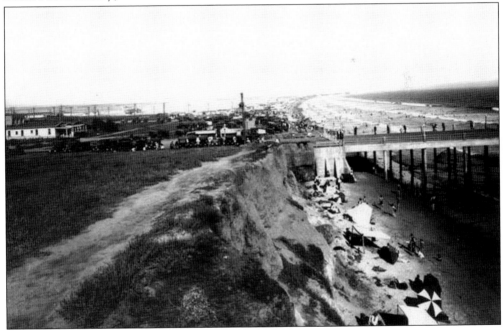

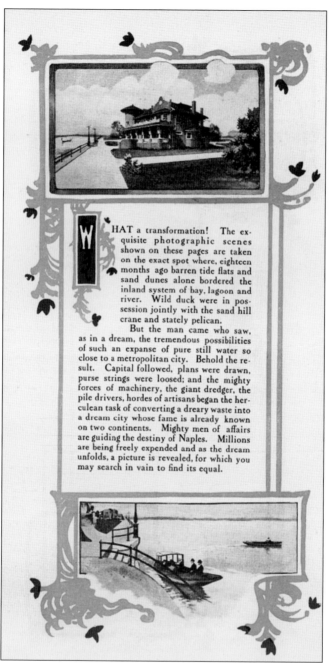

WHAT a transformation! The exquisite photographic scenes shown on these pages are taken on the exact spot where, eighteen months ago barren tide flats and sand dunes alone bordered the inland system of bay, lagoon and river. Wild duck were in possession jointly with the sand hill crane and stately pelican.

But the man came who saw, as in a dream, the tremendous possibilities of such an expanse of pure still water so close to a metropolitan city. Behold the result. Capital followed, plans were drawn, purse strings were loosed; and the mighty forces of machinery, the giant dredger, the pile drivers, hordes of artisans began the herculean task of converting a dreary waste into a dream city whose fame is already known on two continents. Mighty men of affairs are guiding the destiny of Naples. Millions are being freely expended and as the dream unfolds, a picture is revealed, for which you may search in vain to find its equal.

ALAMITOS BAY AND NAPLES. As the page from the original marketing brochure indicates, in 1905, Arthur Parson and his son developed a tract of Bixby Slough marshland at the mouth of the San Gabriel River. They envisioned duplicating an in-land bay and residential area along canals that were similar to those in Italy, complete with high arching bridges and "gay gondoliers." The dredging to fill the island and the installation of concrete bulkheads to push back the water were done at considerable expense. All the homes built were to be white and to have red tile roofs. The landfill would raise the homes to a level high above tides. Building restrictions were put in place to prevent low-income housing.

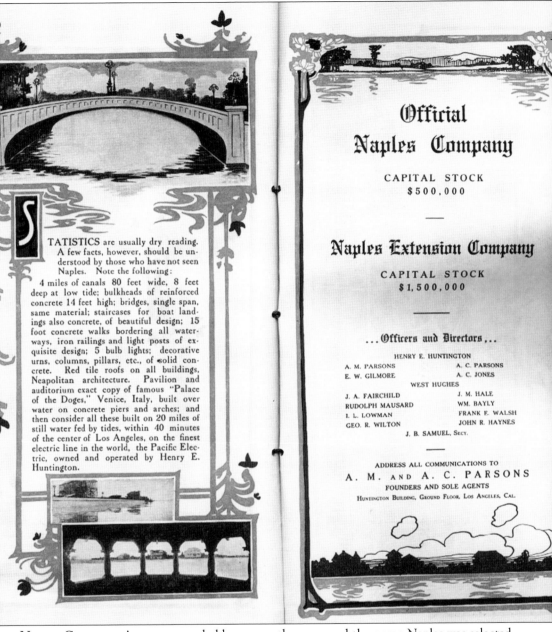

TATISTICS are usually dry reading. A few facts, however, should be understood by those who have not seen Naples. Note the following:

4 miles of canals 80 feet wide, 8 feet deep at low tide; bulkheads of reinforced concrete 14 feet high; bridges, single span, same material; staircases for boat landings also concrete, of beautiful design; 15 foot concrete walks bordering all waterways, iron railings and light posts of exquisite design; 5 bulb lights; decorative urns, columns, pillars, etc., of solid concrete. Red tile roofs on all buildings, Neapolitan architecture. Pavilion and auditorium exact copy of famous "Palace of the Doges," Venice, Italy, built over water on concrete piers and arches; and then consider all these built on 20 miles of still water fed by tides, within 40 minutes of the center of Los Angeles, on the finest electric line in the world, the Pacific Electric, owned and operated by Henry E. Huntington.

Official Naples Company

CAPITAL STOCK
$500,000

Naples Extension Company

CAPITAL STOCK
$1,500,000

...Officers and Directors...

HENRY E. HUNTINGTON

A. M. PARSONS	A. C. PARSONS
E. W. GILMORE	A. C. JONES

WEST HUGHES

J. A. FAIRCHILD	J. M. HALE
RUDOLPH MAUSARD	WM. BAYLY
I. L. LOWMAN	FRANK F. WALSH
GEO. R. WILTON	JOHN R. HAYNES

J. B. SAMUEL, SECY.

ADDRESS ALL COMMUNICATIONS TO

A. M. AND A. C. PARSONS

FOUNDERS AND SOLE AGENTS

HUNTINGTON BUILDING, GROUND FLOOR, LOS ANGELES, CAL.

NAPLES COMPANY. A contest was held to name the area, and the name Naples was selected. Alamitos Bay and Naples were eventually connected to Long Beach and Newport Beach via electric trolleys, in no small part because H.E. Huntington was president of the Naples Company. Parson envisioned the same type of development that he completed in Venice, California. To make the Naples area more attractive to investors, a duck club was built on the San Gabriel River near Anaheim Road. The marketing brochure details the features of the development and a stock offering for the Naples Extension Company.

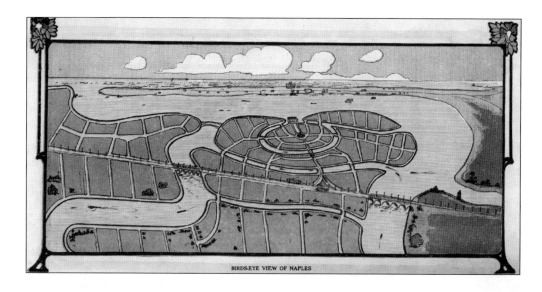

BIRDS-EYE VIEW OF NAPLES

COMPARISON VIEWS OF NAPLES. A drawing from the Naples marketing brochure shows a birds-eye view of the design of Naples island and its relationship to the ocean, Alamitos Bay, and the San Gabriel River. The 1922 photograph shows the actual layout of the area. Alamitos Bay is on the middle left and Treasure Island and Naples to the immediate right. Belmont Pier can be seen in the distance, and oil derricks outline Signal Hill on the far right. The areas containing Alamitos Bay and Naples were annexed by Long Beach in 1923. (Above, author's collection; below, Long Beach Public Library.)

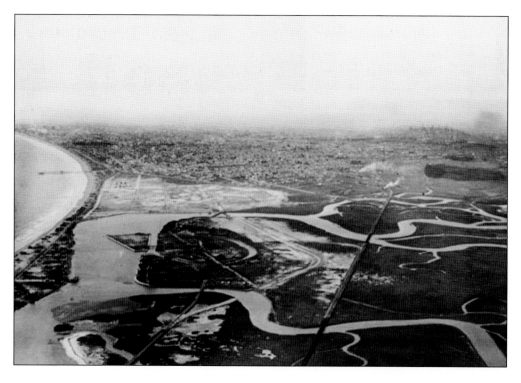

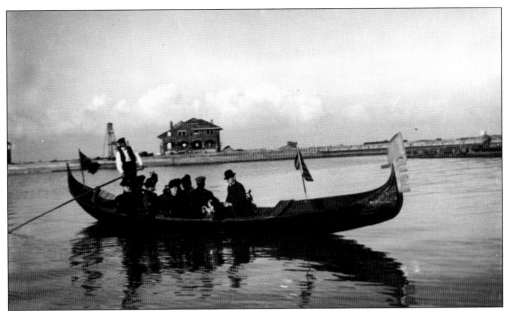

GAY GONDOLIERS. The area featured residences and summer homes. Motorboats and gondolas steered by local gondoliers added to the efforts to make the area a replica of Italy. The Naples Hotel (advertised as Hotel Napoli) was developed by Almira Hershey, a distant member of the Hershey chocolate empire. The Hotel Napoli did not open until 1929 and closed within two years because of the Depression. The 1933 earthquake damaged many of the bulkheads, bridges, and sea walls in Naples, which were repaired with federal and local funds. (Above, Los Angeles Public Library; below, Poly High School Annual.)

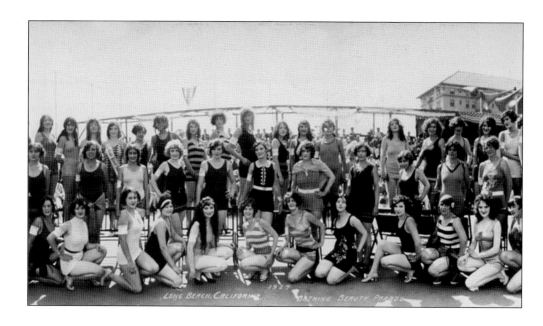

A REAL BEACH TOWN. In 1920, the Long Beach City Council passed an ordinance outlawing the wearing of any bathing suit that did not completely seal the view of the body from the armpits to "one third of the way to the knee joint." Violators could be fined $300 or jailed six months. The city earlier passed an ordinance that outlawed public display of affection between the opposite sexes. Long Beach became the laughing-stock of the national news because of the ordinances, and by 1923, the council had not only repealed the ordinances but began making plans to sponsor a "bathing beauty parade" at the beach, as shown in these 1927 photographs from the Library of Congress. In 1952, the city began sponsoring the Miss Universe beauty contest at the Municipal Auditorium. (Both, Library of Congress.)

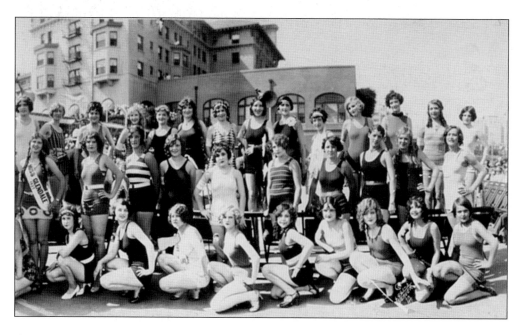

Four

BUILDING A CITY

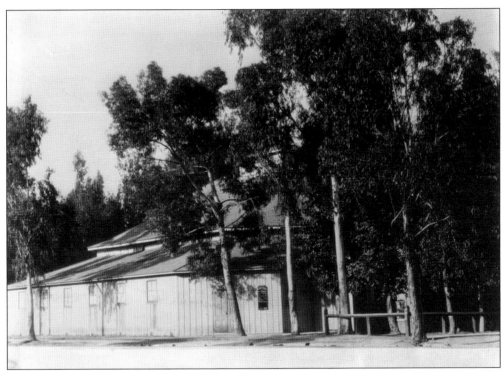

LONG BEACH RESORT ASSOCIATION. A part of William Erwin Willmore's plans included land for a college, which he hoped the Methodists would purchase. In order to entice the church to locate there, land was provided at American and Locust Avenues and Third and Fourth Streets for a tabernacle where members could meet. The Methodist Resort Association held its Chautauqua each summer in Long Beach, attracting thousands. (Long Beach Public Library.)

LONG BEACH ✳

The Chautauqua of Southern Califo

Is an All-the-year-round Health Re:

TWENTY miles south from Los Angeles, on high, fertile fruit la sloping to a beautiful driving and bathing beach, and over ing California's second important harbor. It is connected all transcontinental roads by two lines from Los Angeles wharves, fishing and oyster beds; view of islands, shipping snow-capped mountains, and groves in luxuriant perfec lemons, olives, apricots, nectarines, prunes, peaches, figs, ap berries, and numerous other fruits, grains, and vegetables. On adjacent Alamitos are fine, rich garden and fruit tracts, of from on forty acres, with one share of artesian water stock for each acre. 'I are being improved by our best people, and if desired, can be purch n long time and low interest. The climate is even, and curative of nervous, dyspe tarrhal, and bronchial diseases, and the water is excellent, abundant, and medicinal.

Thunder storms, excessive heat, and fierce winds are unknown, "but everlas pring abides, and never-withering flowers." $1,250 will pay for five acres set in len 'ith three years' cultivation when income begins.

Inquiries addressed to G. S. Trowbridge, City Clerk, Long Beach, Los Angeles Cou alifornia, or Will F. Sweeney, Secretary Alamitos Land Co., will be accurately and ch lly answered.

CHAUTAUQUA ASSEMBLY. The Chautauqua movement started in 1874 at Lake Chautauqua in New York as a summer camp program to provide training for Sunday school teachers. It evolved to provide rural and small towns with a program of performers and lecturers. The 1884 encampment at Long Beach convinced the Methodist Church that it should establish a Chautauqua Assembly there in 1885. Founders praised the location as "central and accessible" and noted that in a six-month period of time, Long Beach had progressed from "little more than a sheep ranch" to a splendid location with a fine hotel, a mild climate, cottages and tents on the beach, and fresh artesian water brought three miles in "iron cast pipes." The Long Beach Chautauqua offered a variety of lectures on such topics as photography, child development, music, cooking, art, the Bible, and juggling.

METHODIST CHURCH. Long Beach CAL.

THE HEAVENLY CITY. The influence of the Methodists upon the formation of the city of Long Beach cannot be understated. Several of its members were part of the Long Beach Land and Water Company, which took over the plan of William Erwin Willmore, and they supported Willmore's plan to have an alcohol-free city. Because of the prohibition, church publications wrote about Long Beach, saying "the moral atmosphere of the city is heavenly." As the number of Methodists who were permanent residents increased, so did the need for a church. The First Methodist Church was initially located on Pine Avenue at Fifth Street in 1899. A larger church was built in 1909 at the corner of Fifth Street and Pacific Avenue. By the late 1920s, there were numerous Methodist churches throughout the city, as well as Presbyterian, Baptist, Friends, Congregational, Christian Science, Episcopal, Lutheran, Catholic, Jewish, Unitarian, Church of Christ, and Spiritualist. The city's first Salvation Army headquarters opened in 1907.

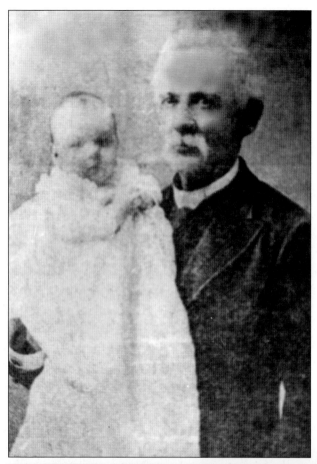

LONG BEACH IS INCORPORATED. On January 39, 1888, 106 residents voted to incorporate the city, and 103 voted in favor, selecting the following five trustees: Thomas Stovell, John Roberts (pictured at left holding baby), George H. Bixby, I.D. Fetterman, and M.H. La Fetra. Voters also selected a city treasurer, W.W. Lowe; a city clerk, W.H. Nash; and a marshal and tax collector, H.A. Davies (pictured below with a marshal's star). Roberts was selected by his colleagues as president of the board of trustees. The official boundaries of the new city included the following areas: north to Hill Street, west to the old San Gabriel River, and east to Alamitos Avenue. (Both, Long Beach Public Library.)

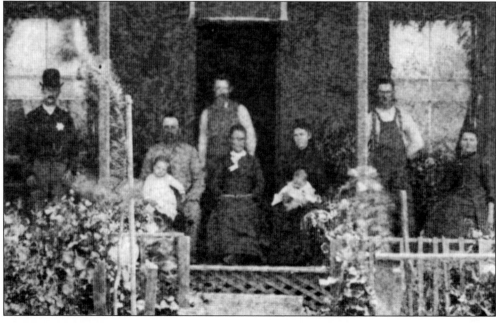

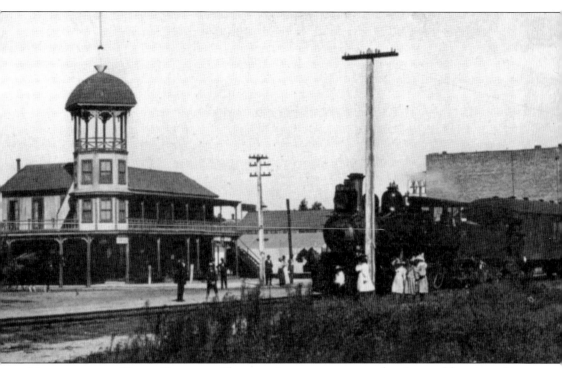

MEETING AT THE TOWER BUILDING. The new city government set the time and location of its meetings. The board of trustees selected the Tower Building at the corner of Pacific and Ocean Avenues. It also passed ordinances to tax businesses, to pay $5 a day for a civil engineer, and to grant a franchise to the Los Angeles and Ocean Railways. Because state law required cities of the sixth class to hold elections in April every two years, Long Beach had a second election just months later after incorporation. The new board of trustees promptly enacted a dog tax, a poll tax on males ages 21 to 55, and a formula for assessing property taxes. A stringent prohibition ordinance was also enacted.

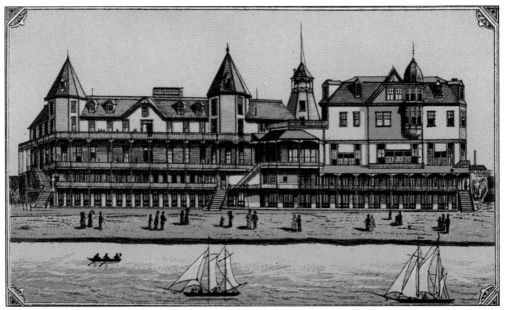

CALL FOR DISINCORPORATION. Liquor was not allowed in Long Beach, even at the city's most popular tourist spot, the Long Beach Hotel. The real estate boom ended and residents began turning against the city government, complaining about taxes and a lack of improvements to the city. When the Long Beach Hotel, Long Beach's prime tourist spot, burned to the ground on November 8, 1888, residents started calling to disincorporate the city and allow the County of Los Angeles to take over.

Prohibition in Long Beach

An interview with a reputed resident of Long Beach on the effect of prohibition in that city, as printed in the Californian last week, attracted the attention of Rev. Lloyd C. Smith of the First Baptist Church, and he has writen and received letters from the southern town which will be of interest.

ANTI-PROHIBITION DRIVES DISINCORPORATION. Newspaper accounts (such as this one in the *Bakersfield Tribune*) indicate that the real reason for the call for disincorporation was the understanding by the anti-prohibition faction that without a local government, there would be no laws against saloons. Residents voted on July 27, 1896, to disincorporate by a vote of 132 to 126. The case went to the California Supreme Court, which upheld the disincorporation in June 1887. The city's assets were given to the county.

(Conducted by the National Woman's Christian Temperance Union.)

SALOONLESS SEASIDE RESORT.

Probably the finest example of a popular amusement and recreation resort, as absolutely successful as it is dry, is Long Beach, Cal., writes a W. C. T. U. woman of southern California. Since the voting out of the saloon 13 years ago, she tells us, the growth and development of Long Beach has been both rapid and substantial, the census returns for the decade, 1900-1910, showing an increase in population of 691 per cent. In 1900 the saloons were voted out by a strong majority, and this position was strengthened last January by an iron-clad no-license charter amendment which prohibits hotel licenses and any importation of liquor into the dry territory.

In 1900 the bank deposits were $140,000; children in schools, 1,829; homes, 628; churches, four, and lumber yards, one. Today, the bank deposits are $8,600,000; bank capital stock, $900,000; surplus, $412,757; school children, 5,580; homes, 5,220, and the single lumber yard has grown to 13. Real estate values have advanced, in the business area, from $350 a lot to $60,000 in the 13 years, with a corresponding gain in realty in every direction.

So strong is "dry" sentiment in Long Beach that including the 15 drug stores not more than 20 people hold United States revenue receipts.

BUTTERMILK, GRAPE JUICE, AND RESPECTABILITY. Long Beach's reputation as a "moral city" largely came from it being one of the few cities that adopted prohibition, placing alcohol restrictions in all land deeds except for hotels. In a Kansas newspaper, the Woman's Christian Temperance Union attributed Long Beach as the "fastest growing city" because it was "saloonless." W.R. Porterfield of the *Freeport Journal* in Freeport, Illinois, who wrote in 1922 (and penned the editorial cartoon shown below), agreed that prohibition was the only reason for "the remarkable growth of this remarkable city." Porterfield pointed out in his column that early on Long Beach had shown the world that "buttermilk and grape juice carried no sting." Long Beach resident Marie C. Brehm lectured on the Chautauqua circuit both on feminism and prohibition. In 1924, she ran for vice president of the United States on the Prohibition Party ticket.

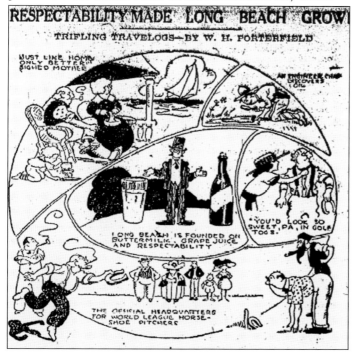

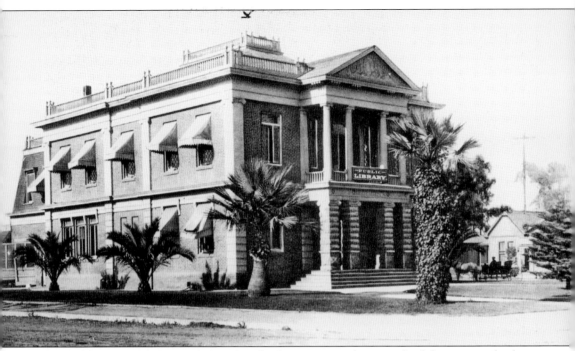

CONSTRUCTING A CITY HALL. As Los Angeles County enacted taxes to fund the repair and upkeep of the former city of Long Beach, residents again circulated a petition calling for incorporation. On December 1, 1897, voters approved incorporation on a vote of 237 to 37. A loosening of restrictions on alcohol was passed, which allowed the following: one saloon, alcohol with a doctor's order, and service of alcohol at hotels with 15 rooms. The board of trustees became the board of freeholders, and in 1907, it adopted a charter that included prohibition. In 1899, the cornerstone was laid for the city hall.

A NEWER CITY HALL.
Long Beach city government quickly outgrew the first city hall and rented space throughout the city. In 1919, a $400,000 bond election was passed for a new eight-story city hall. The ground-breaking was held on May 26, 1921, and the police department was the first to occupy the building in July 1922. The city hall also provided space for the superior court. The city changed its form of government to a city manager–council. Following the 1933 earthquake, the city hall was repaired, reinforced, and modernized in its appearance. A Veterans Memorial and Municipal Utilities Building were also constructed to the left of city hall.

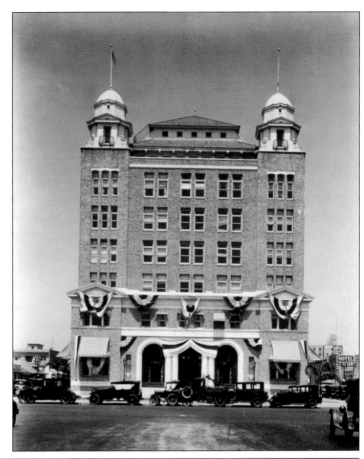

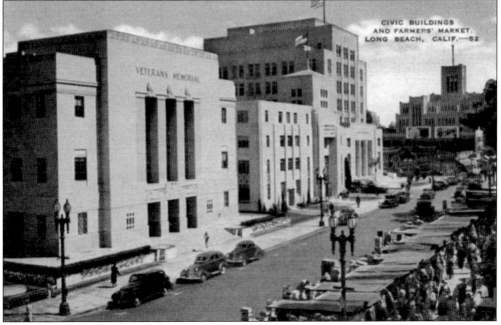

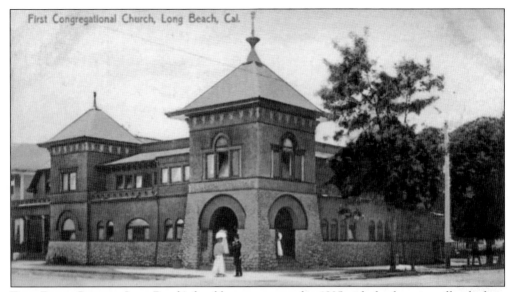

First Congregational Church, Long Beach, Cal.

FIRST PUBLIC LIBRARY. Long Beach's first library was started in 1895 with the donation of books from the Woman's Christian Temperance Union (WCTU) to a reading room in the First Congregational Church. The minister called for a public library and reading room in order to draw residents away from the only saloon in town. The church was founded by Jotham and Margaret Hathaway Bixby and 14 other locals. The church initially met in Cerritos Hall at Third Street and Cedar Avenue, the site at which the church was constructed and still remains. A reading-and-writing room was also established on Pine Avenue and could be accessed for a 5¢ admission fee.

ALAMITOS LIBRARY ASSOCIATION. In 1895, women in the Alamitos Tract organized the Alamitos Library Association (shown). They were given land by Jotham Bixby for a library. The Alamitos Library became a branch library of Long Beach in 1910 after the city annexed the area. A Long Beach Library Association was also formed, and its members helped raise funds with events at the Ebell Club. In 1902, voters approved a library tax. (Long Beach Public Library.)

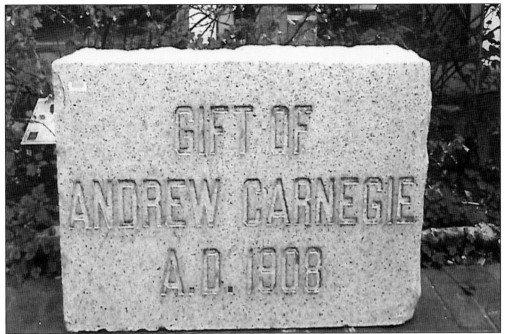

CARNEGIE LIBRARY. Steel magnate Andrew Carnegie helped fund public libraries throughout the United States. Monies were given by Carnegie if there was a need for a public library and the city would donate property and would provide for the library's continued support. Long Beach applied for Carnegie funding in 1902, while the city pursued a parcel of land from the Long Beach Land and Water Company in the middle of Pacific Park. Before the library could be constructed, the Minnie the Whale exhibit had to be removed from the park, and the Land and Water Company agree that a library could be placed on park property. Carnegie donated $30,000 to Long Beach, which added $4,400 for the library's construction. The cornerstone was laid on September 5, 1908. The library opened May 29, 1909.

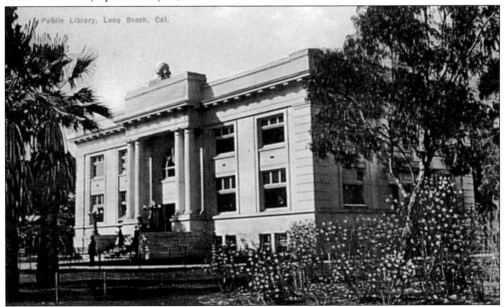

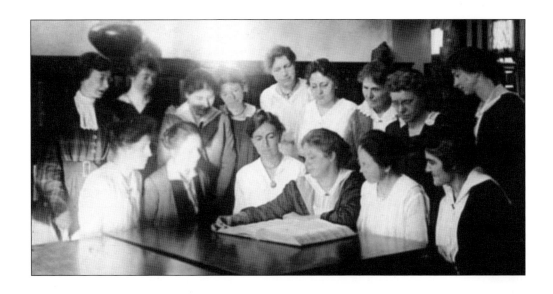

FIRST LIBRARIANS. Use of the Long Beach Public Library increased rapidly. Victoria Ellis, named as the first librarian, was replaced in 1914 by Zaidee Brown (shown with a library book and other librarians), who served until 1921, when Theodora Brewitt was appointed. Over the next few years, several branch libraries were added: Burnett, Zaferia (east Long Beach), Belmont Heights, and North Long Beach. By 1926, the Long Beach Public Library circulated 100,000 books and periodicals and 50,000 residents held library cards. The first bookmobile in the area was used to reach local readers. (Both, Long Beach Public Library.)

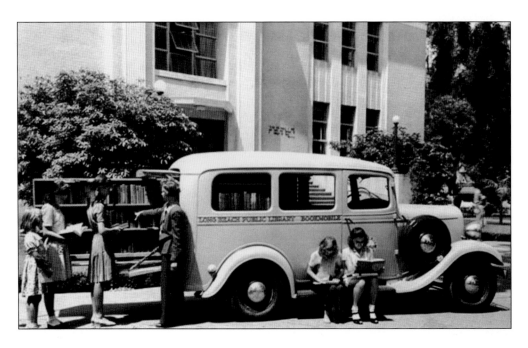

MARKETING CONTINUES. The Interstate Commerce Commission designated Long Beach as a freight terminal point for the railroads in 1911. The Pacific Electric Railway expanded its trolley lines in Long Beach. Real estate boomed again, and marketing advertisements appeared in publications across the United States touting the benefits of living in Long Beach, which were the following: parks, artesian wells, mild climate, beachfront access, and numerous schools. Population continued to grow, as did the development of water, electricity, telephone, and telegraph franchises. The *Oskosh Daily Northwestern* newspaper reported in 1906 that Long Beach had a population of 16,000 and "250 real estate officers," who owned automobiles and gave rides to prospective buyers when they visit the city.

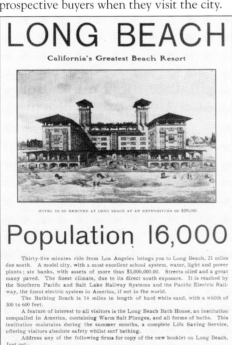

LONG BEACH

California's Greatest Beach Resort

HOTEL TO BE ERECTED AT LONG BEACH AT AN EXPENDITURE OF $350,000

Population 16,000

Thirty-five minutes ride from Los Angeles brings you to Long Beach, 21 miles due south. A model city, with a most excellent school system, water, light and power plants; six banks, with assets of more than $3,000,000.00. Streets oiled and a great many paved. The finest climate, due to its direct south exposure. It is reached by the Southern Pacific and Salt Lake Railway Systems and the Pacific Electric Railway, the finest electric system in America, if not in the world.

The Bathing Beach is 14 miles in length of hard white sand, with a width of 300 to 600 feet.

A feature of interest to all visitors is the Long Beach Bath House, an institution unequalled in America, containing Warm Salt Plunges, and all forms of baths. This institution maintains during the summer months, a complete Life Saving Service, offering visitors absolute safety whilst surf bathing.

Address any of the following firms for copy of the new booklet on Long Beach, Just out:

F. W. Stearns, Real Estate.	Townsend-Dayman Investment Co., Real Estate.
Mayhew & Putnam, Real Estate.	
Geo. H. Blount, Real Estate.	Long Beach Bath House Co.
Frank P. Pingree, Real Estate.	J. W. Wood.
Shaw & Gundry, Real Estate.	L. A. Perce.
E. C. Covert & Co., Real Estate.	Young & Parmley.
Walker Real Estate Co.	J. M. Holden.
Seaside Water Co.	C. J. E. Taylor.
The National Bank of Long Beach.	Alamitos Land Co., Real Estate.

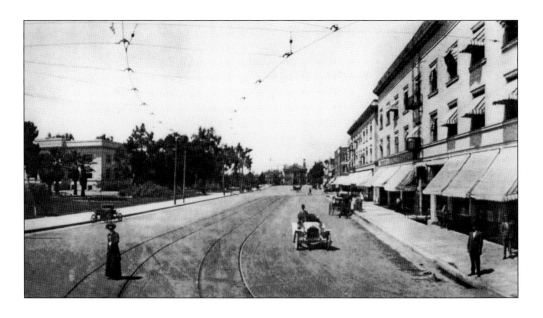

Long Beach Business District. Long Beach promoted the development of a business district in the 1906 photograph above, which shows the public library (on left) and city hall at the end of the street adjacent to numerous shops and a handful of shoppers. The Red Car trolleys brought residents and others from surrounding areas to the business district. In 1903, a group of business owners organized the board of trade and established its headquarters on Pine Avenue. By 1909, a chamber of commerce was formed, advocating a Long Beach harbor and more residents. It adopted this theme in 1914: "Harbor, Homes, Health and Happiness—Long Beach 100,000 in 1920." (Above, Long Beach Parks, Recreation, and Marine Department; below, Long Beach Transit.)

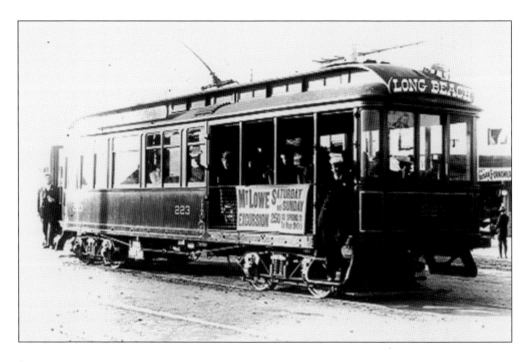

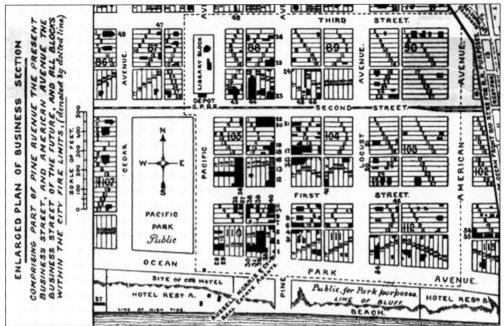

STORES AND SHOPS. The business section was planned in the late 1880s to include Pine and American Avenues as major business streets, as shown in this visitor's guide. The guide features numbered locations of the businesses that operated in the earliest days of the city and included (among others) one blacksmith, coal, wood, and hay-and-grain stores, and a billiard hall that offered "first-class tables, cigars, tobacco, and temperance drinks." In the 1887 photograph below, Wingard's Central Pharmacy is shown at 27 Pine Avenue. It provided space for one of Long Beach's 10 doctors, J.W. Wood. An additional pharmacy was at 148 Pine Avenue. The guide lists two dentists and two undertakers. (Above, Long Beach Public Library; below, author's collection.)

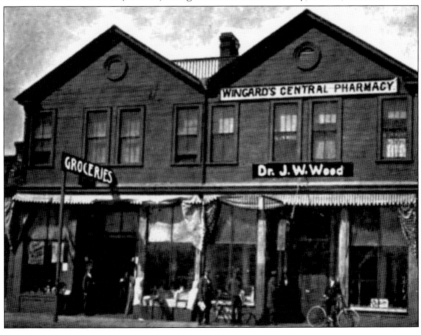

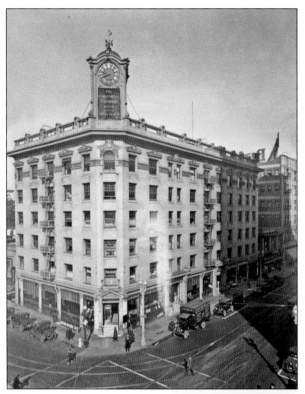

THE NATIONAL BANK OF LONG BEACH. The first bank in Long Beach opened in 1896 at the corner of Pine and Ocean Park Avenues (pictured as tallest building on right). The Bank of Long Beach was headed by Jotham Bixby as president and P.E. Hatch and Charles L. Heartwell as cashier and assistant cashier, respectively. The Bank of Long Beach became the National Bank of Long Beach and was merged with a savings bank started by the same founders to become Long Beach Trust & Savings Bank, which in turn became Long Beach Security Trust & Savings and later the Security–First National Bank. Numerous other banks opened in Long Beach, and in 1907, C.J. Walker established the Farmers & Merchants Bank at 227 Pine Avenue. In 1923, the bank moved to its present location at Third Street and Pine Avenue. (Both, Long Beach Public Library.)

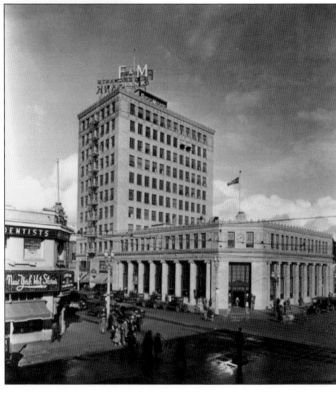

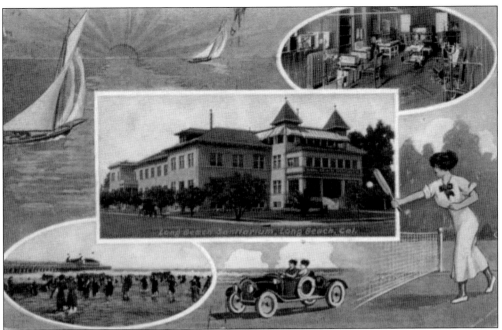

A PLACE TO GET HEALTHY.
The mild climate and ocean breezes attracted people who lived in crowded, unhealthy cities in other states and who sought cures for a number of ailments, including tuberculosis. Advertisements for hotels and vacations were featured next to announcements about the "Long Beach Sanitarium," a West Coast annex of the sanitarium in Battle Creek, Michigan. The facility was sold in 1923 to the Sisters of Charity of the Incarnate Word, who still operate St. Mary Medical Center at that location.

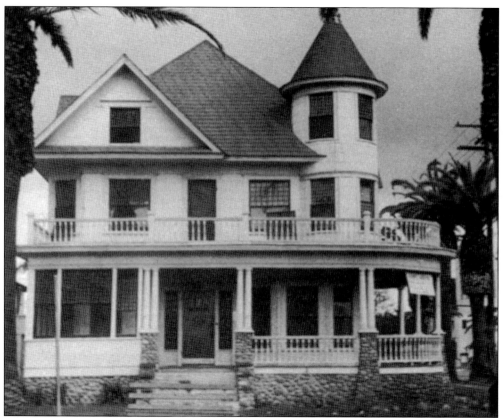

SEASIDE HOSPITAL. Dr. W. Harriman Jones helped organize Seaside Hospital. In 1907, Seaside Hospital opened in a house at the northeast corner of Broadway and Junipero Avenue. In 1913, two lots were purchased from a farmer near Magnolia Avenue and Fourteenth Street, and Seaside Hospital was expanded to 31 rooms. By the late 1950s, the hospital included several buildings. In 1960, private patients were transferred to the newly constructed Memorial Hospital of Long Beach. Seaside Hospital became a county facility and was renamed El Cerrito Hospital. The facility became a Los Angeles County Comprehensive Health Center. In 1930, Jones opened the 47-bed Harriman Jones Clinic Hospital at Cherry Avenue and Broadway. He practiced medicine in Long Beach from 1901 until 1956. (Both, Long Beach Public Library.)

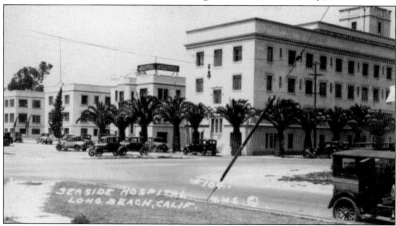

COMMUNITY HOSPITAL. The voters approved a $100,000 public hospital bond in 1922 that resulted in the building of Community Hospital on city-owned property on Termino Avenue. The 125-bed hospital opened on July 24, 1924. The city provided funds and a nominal lease of $1 a month on the condition that the hospital provide free or low-cost hospital care for residents. The city provided clinic care through its own public health department. Community Hospital remains at the original location and is now managed by the Memorial Health Care system.

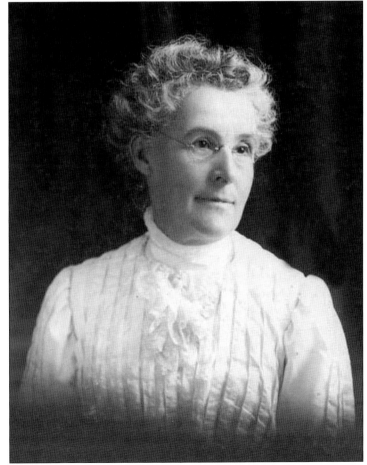

ADELAIDE TICHENOR. Adelaide Tichenor helped endow an orthopedic school and hospital adjacent to Community Hospital in 1926. Children with infantile paralysis were treated at the orthopedic hospital during the 1940s. Her philanthropy extended to funding the Ebell Club, an Episcopal church, the public library, and the Long Beach Day Nursery, to which she donated a lot at 805 Alamitos Avenue and an eight-room house on Locust Avenue. (Long Beach Public Library.)

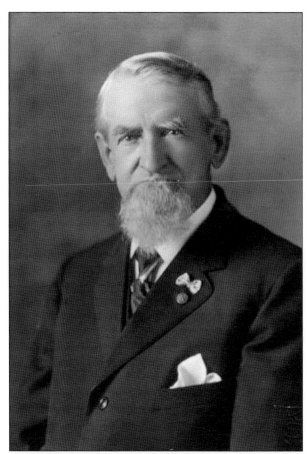

FIRST HEALTH OFFICER AND BAND LEADER. From the start of the city, Long Beach provided residents access to public health. Its first health officer in 1887 was Dr. W.L. Cuthbert, a former first assistant surgeon in the Civil War. After the war, Cuthbert trained in New York at Columbia and Bellevue Hospital. He moved to Belle Plain, Kansas, and then to Long Beach after a visit to find property. In addition to attending to his medical duties, Doctor Cuthbert formed the first band in the city in 1901 with members of his family. Cuthbert played the horn and the drum (shown below). Cuthbert is buried in the Long Beach Municipal Cemetery. (Both, Long Beach Public Library.)

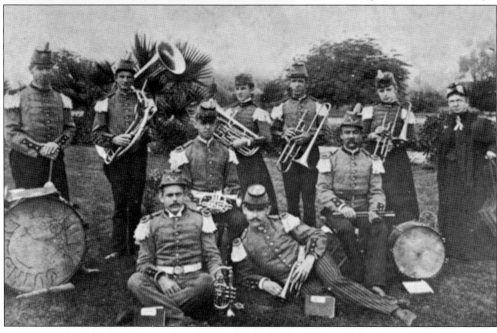

MUNICIPAL BAND. The beach strand attracted musical performers who were able to make a substantial income from the concerts and the dances. Several Italian bands dominated the beach area. The city wanted to remove the foreigners and established in 1909 an American band under the direction of E.H. Wiley. Voters approved a tax to pay for the Long Beach Municipal Band.

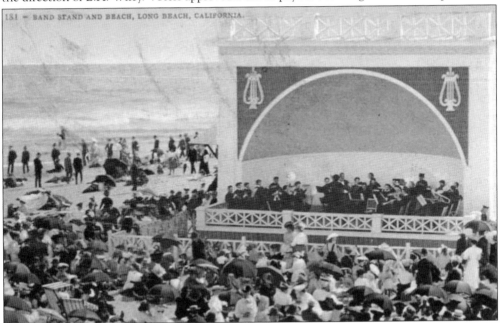

BAND STAND. A beach bandstand and pergola were constructed in 1911 south of East Seaside Boulevard. The band performed daily concerts (except for Mondays) and toured local areas. In 1915, Osa F. Foster took over as conductor and increased the size of the band. In 1923, Herbert L. Clarke replaced Foster. Clarke served as assistant conductor of John Philip Sousa's band. Clarke brought national attention to the Long Beach Municipal Band and significantly improved its performances.

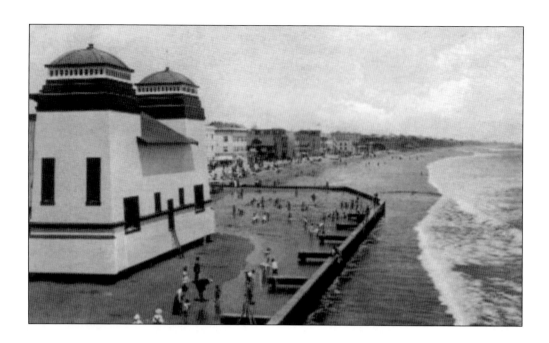

AT THE MUNICIPAL AUDITORIUM. In addition to the concerts on the beach, the Municipal Band performed to large crowds at the Municipal Auditorium until the Depression. During hard economic times, the city laid off the band periodically, including for several months after the 1933 earthquake. The band members donated their time to perform for residents as a way to cheer up people during the hard times. The band tax was eventually eliminated. The Municipal Band continues to perform each summer in several Long Beach parks.

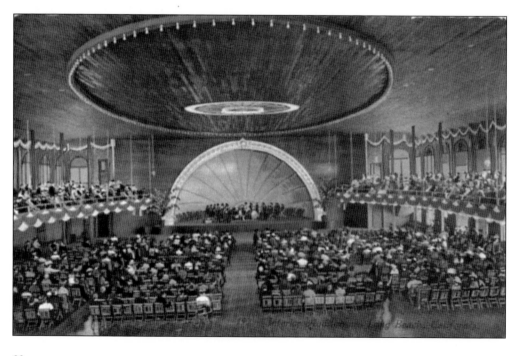

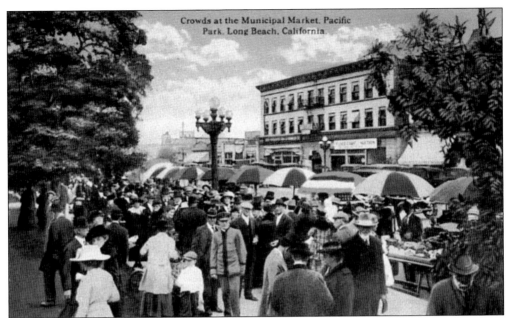

Crowds at the Municipal Market, Pacific Park, Long Beach, California.

MUNICIPAL MARKET. Local entrepreneur Squire DuRee organized the Municipal Market at Pacific Park in 1913. The market continued for many years and featured a variety of concessionaires who paid 50¢ a day for a stall on Tuesdays, Thursdays, and Saturdays. Flowers and food were sold at 112 stalls and featured vendors of all nationalities. DuRee, later became city superintendent of recreation and promoted several aviators, who flew over the municipal market to draw business. In 1911, DuRee was also instrumental in the city purchasing three parks and making certain that local lifeguards were equipped with rescue boats, making Long Beach the first city to do so.

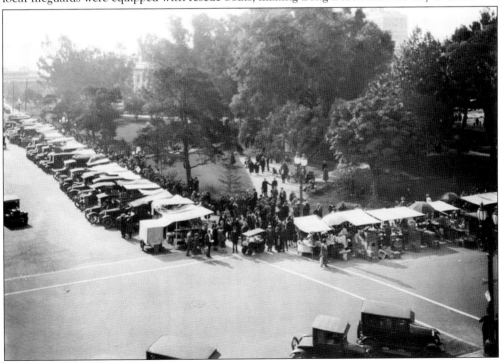

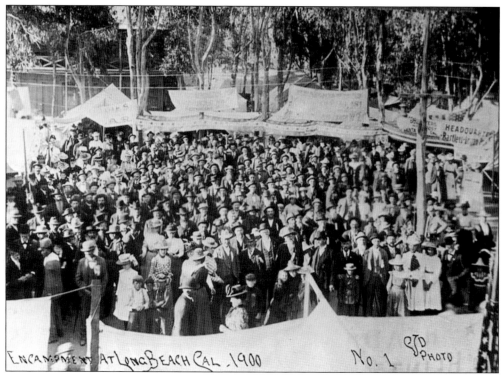

GRAND ARMY OF THE REPUBLIC (GAR) POST 181. After the Civil War, many soldiers and their families moved to the Long Beach area because of the climate and business and farming opportunities. Consequently, Long Beach was home to one of the largest groups of Civil War veterans, who formed the GAR Post 181. The post held annual encampments in Bixby Park. The group spearheaded patriotic events and fundraising for an Abraham Lincoln monument. Over 1,200 Civil War veterans are buried at the Municipal and Sunnyside Cemeteries.

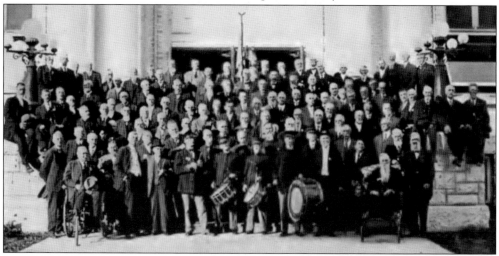

BLUE AND GREY CLUB AND DRUM CORPS. Long Beach was also home to the only Blue and Grey Club that included both Union and Confederate members, who met socially and discussed political issues. Club members were given Johnny-and-Yank enamel pins. The group formed a drum corps, which practiced in the municipal auditorium.

LINCOLN PARK. On June 28, 1915, the cornerstone was laid for the Abraham Lincoln Grand Army of the Republic Memorial Monument in what was then Pacific Park near the public library. It took the Citizens Monument Association 10 years to raise the funds for the eight-ton granite statute, which was a copy of the Lincoln figure in Chicago sculpted by Augustus St. Gaudens. Chiseled by the Long Beach Monument Works, which was managed by F.E. Brittain, the statute included the names of famous Civil War commanders and the battles in which they fought. A replica of a Springfield musket used in the Battle of Chickamauga is on the base. A cannon was sent by the Benicia Arsenal for the dedication ceremonies. The official dedication ceremony was held on July 3, 1915, and included an offshore 21-gun salute from the gunboat USS *Chattanooga*, sent by naval secretary Josephus Daniels. A banquet was held at the Hotel Virginia. Pacific Park was renamed Lincoln Park in 1920.

..Souvenir..

ABRAHAM LINCOLN
G. A. R. MONUMENT
LONG BEACH, CAL.

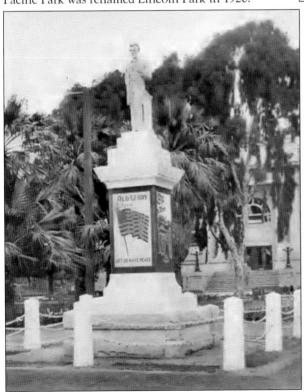

HOUGHTON PARK. Col. Sherman Otis Houghton lived a colorful life as a soldier in the Mexican-American War, a gold miner, a councilman and mayor in San Jose, an attorney, an officer in the Civil War, and a member of US Congress. In 1896, he purchased a large farm in North Long Beach, and he resided there until his death in 1914. In 1924, his family donated several acres of his property in his memory, and the city established Houghton Park, which was later expanded with the purchase of 24.88 acres from the Houghton family.

SECOND CITY SEAL. The first city seal was designed in the early 1900s and consisted of a ship sailing along the coast of Long Beach. In 1930, a contest was sponsored by the chamber of commerce with a prize of $150. The winning design was drawn by an employee in the city engineer's office, Roland S. Gielow. Gielow's design included what were then considered to be symbols that best represented Long Beach. (Long Beach City Clerk.)

OFFICIAL SEAL. Most of Gielow's design was officially adopted on September 23, 1930. The four stars signified Long Beach as the state's fourth largest city, and the smoke from the Edison plant was removed. The rest remains, such as the following elements: *Urbs Amicitiae* (Friendly City), an airplane, the port, an oil derrick and the Edison plant, a long beach, the municipal auditorium and rainbow lagoon, the Queen of the Beaches, a California bear, a horn of plenty, and a lamp and book (to symbolize the city's cultural side). (Long Beach City Clerk.)

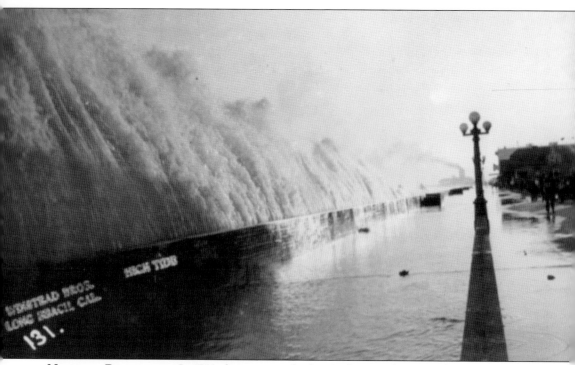

NEEDING A BREAKWATER. In 1914, the waves crashed up to the strand area, washing out bulkheads and cement walks and destroying several homes in the Seaside Park and Alamitos Bay areas. Boats used by the Long Beach lifesavers helped rescue people stranded in their homes. The gale-force winds were so strong during the storm that national newspapers reported that the residents thought it was an earthquake that was battering the city. Twenty thousand tons of salt were washed out to sea from the Long Beach Salt Works facility in the harbor area. The need to protect the coastline from high breaking waves eventually led to an extension of the federal breakwater.

Five

MAKING A PORT
AND A BREAKWATER

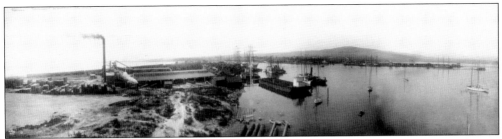

SAN PEDRO BAY. This 1888 photograph shows the inner section of the San Pedro Bay adjacent to Long Beach. The bay was naturally protected, making it easier for ships to dock. Railroad connections were in place by 1869, so that by 1885, San Pedro port was handling 500,000 pounds of cargo a year. Congressman Sherman Houghton secured $200,000 in 1871 to begin establishing San Pedro as the port of Los Angeles. (Library of Congress.)

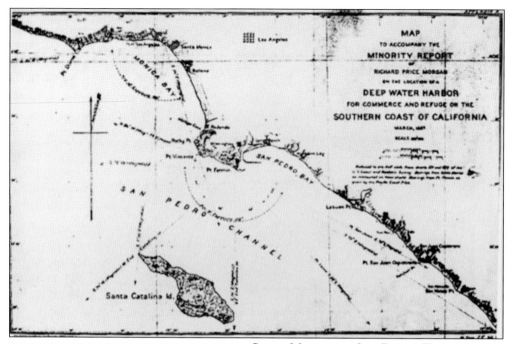

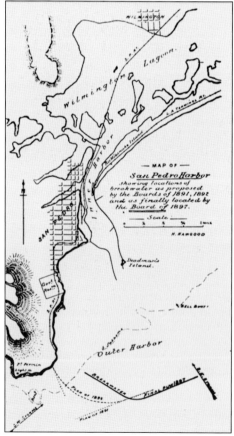

SANTA MONICA VS. SAN PEDRO. Two giants, Collis P. Huntington (head of the Southern Pacific Railroad) and Harrison Gray Otis (owner of the *Los Angeles Times*), battled on behalf of two cities in the 1890s to win designation as the Government Harbor in Southern California. Huntington owned land in Santa Monica and wanted the federal government to fund a port there. Otis argued against a "monopoly harbor" and instead for a "free harbor" at San Pedro. The map shows the location of both potential sites. (Port of Long Beach.)

LONG BEACH JOINS IN. Long Beach joined the fight and spent city funds lobbying on behalf of San Pedro because it believed that locating a deep-water port just five miles away would bring businesses to the city. Long Beach also aligned itself with the Los Angeles Terminal Railway, which monopolized rail access in the area. (Library of Congress.)

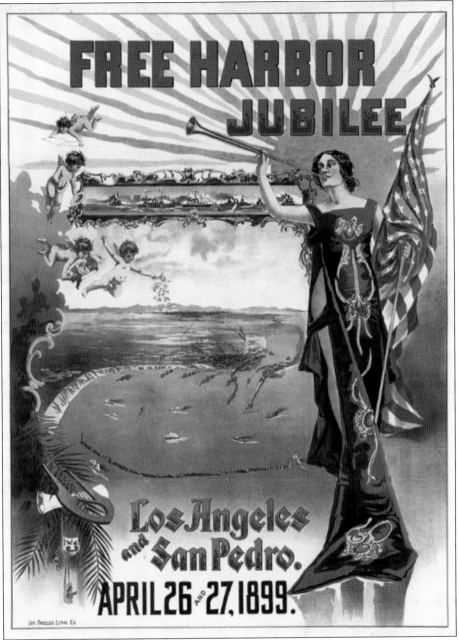

HARBOR JUBILEE. The federal government wanted a deep-water port in Southern California to handle the increase in trade that would result from new Oriental trade and the completion of a Nicaragua canal. In 1897, San Pedro won the designation as the deep-water harbor, which necessitated a widening of the Wilmington inner harbor and a breakwater constructed to provide a calmer entrance. A Harbor Jubilee was held on April 26 and 27, 1899, to celebrate the beginning of a "free harbor" in the Los Angeles and San Pedro areas. Gov. Henry Gage officiated at the ceremonies on the West Coast while in Washington, DC, President McKinley pushed a button to signal the dumping of rock into the ocean, starting the construction of the federal breakwater. (Library of Congress.)

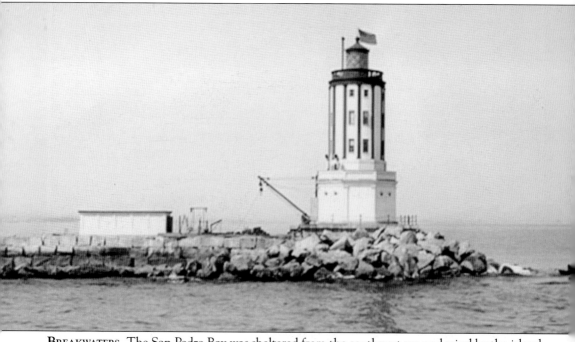

BREAKWATERS. The San Pedro Bay was sheltered from the southwest sea and wind by the island of Catalina, but it was exposed to southeast swells that caused problems during winter storms. Construction of the eastern jetty across the bar started in 1871 and finished 10 years later. The federal board of engineers proposed placing a breakwater at the westerly side of San Pedro Bay to provide a harbor that was "not primarily a harbor of refuge but a port of commerce." It was designed to be 8,500 feet long and 20 feet wide to accommodate railroad tracks, but when finished it was 9,250 feet. The breakwater later was extended to 11,500 feet. It was set to cost $2.9 million. Neu & Heldmaier won the construction contract, and stones were hauled from Catalina Island. (US Coast Guard Archives.)

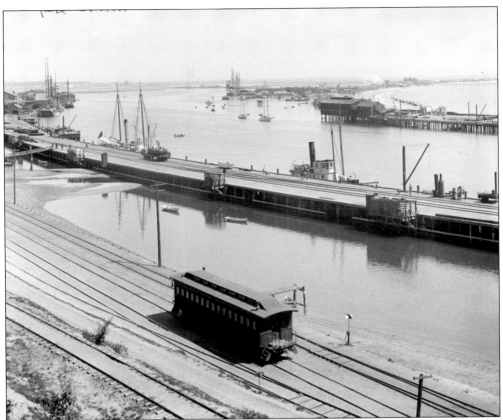

LOS ANGELES HARBOR. As this late 1890s photograph shows, extensive improvements had been made to create both an outer and inner harbor in San Pedro. Railroad connection to the docks was essential to move the goods transported by ships. The Southern Pacific Railroad controlled access to all of San Pedro and Wilmington. Unless a channel could be created between the Los Angeles harbor area and Long Beach, only San Pedro would have a connection to the deep-water ocean. (Library of Congress.)

RATTLESNAKE ISLAND. The mudflat island is situated at the mouth of the Los Angeles River and earned its name due to the snakes that often came out after the area flooded. The island was later named Terminal Island by the Los Angeles Terminal Island Railroad with the thought that it would be the terminal stop on the Salt Lake City–to–Los Angeles route. (Port of Long Beach.)

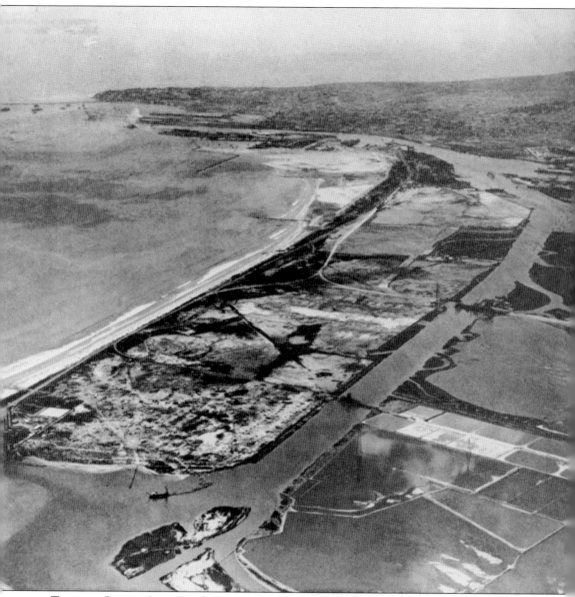

TERMINAL ISLAND. Long Beach attempted to annex Terminal Island and East San Pedro in 1905, but the vote was nullified by the court. In 1909, a 630-acre easterly portion of the island was annexed by Long Beach, moving the city's boundaries even closer to the Los Angeles harbor area. The Los Angeles and Salt Lake Railway constructed a bascule bridge in 1909 across the entrance of the Long Beach Harbor from west Ocean Boulevard to Terminal Island. It was dismantled in 1934 but is seen in this photograph. A 760-foot-long, double-leaf, Strauss Trunnion bascule bridge that spanned the Cerritos Channel, was 4.8 miles upstream of the main Los Angeles/Long Beach harbor entrance, and connected with Badger Avenue was built in 1923 (shown in the photograph). The bridge was designed by Joseph Strauss, who was the designer of the Golden Gate Bridge. (Port of Long Beach.)

San Pedro–Long Beach–Terminal Island Connection. Even before Long Beach annexed the eastern portion of Terminal Island and the bridges were built, the areas were connected by a submarine cable under the inner harbor at San Pedro. The cable was laid by the Long Beach and San Pedro Electric Company under the management of Iva E. Tutt, secretary, treasurer, and general manager. Tutt received the first electricity franchise from the City of Long Beach in 1895 and a similar one from San Pedro in 1897. Her company operated an electric plant in Long Beach that supplied light, heat, and power, and it generated electricity using steam boilers powered by crude oil. The 1898 photograph below shows the switchboard, the engine room, and dynamos. Mrs. Tutt (whose name was often misspelled) is pictured in the center and in the drawing at right. The novelty of a woman operating an electricity franchise was covered by newspapers and engineering journals across the United States.

MRS. EVA E. TUTTS.

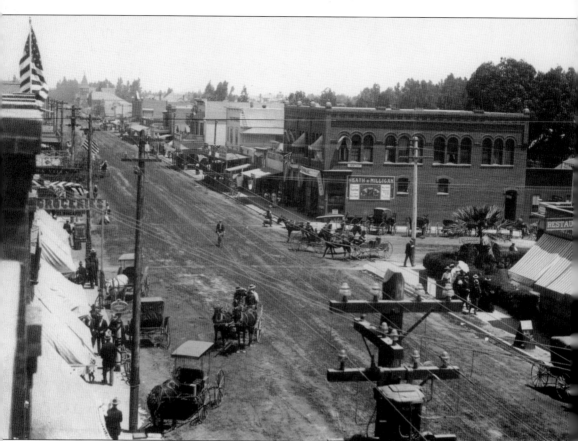

LONG BEACH WANTS A HARBOR. From its earliest days as a city, there was considerable interest in expanding business and industry in the area beyond downtown Pine Avenue (shown above). A business syndicate—the Long Beach Land and Navigation Company—was formed in 1905 by Stephen Townsend to purchase 802 acres of salt tide flats from the Seaside Water Company for $250,000. The syndicate offered incentives to factories and the Pacific Electric Railway to locate there. The plan was to develop 27,000 feet of water frontage. Townsend served as mayor of Long Beach from June 1902 until April 1904. He also served as the president of the American National Bank in Long Beach. In 1905, the Long Angeles Dock and Terminal Company was formed to purchase the acreage for a harbor. (Port of Long Beach.)

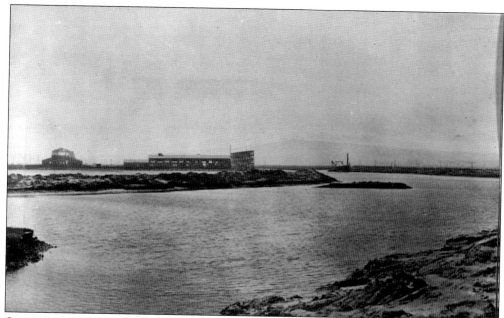

CRAIG SHIPBUILDING. In 1907, John Franklyn Craig came from Toledo, Ohio, to Long Beach and organized the Craig Shipbuilding Company (shown above). The Craig Shipyard provided the only dry dock facility on the West Coast south of San Francisco. Craig became prominent in Long Beach business and became president of the Long Beach Board of Harbor Commissioners from 1931 until 1938. (Port of Long Beach.)

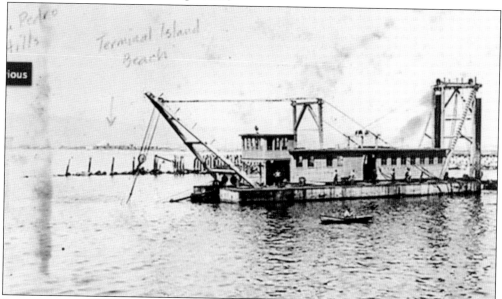

DREDGING BEGINS. By 1909, the Los Angeles Dredging Company and the Western Dredging and Marine Construction Company, owned by John Craig, completed a 21-foot-deep channel that provided an entrance to the Pacific Ocean. The Salt Lake Railroad had built a trestle that blocked a dredger from finishing its work. A court declared that the Cerritos Slough was navigable water and ordered the trestle removed. The railroad built a bascule bridge to span the water. (Port of Long Beach.)

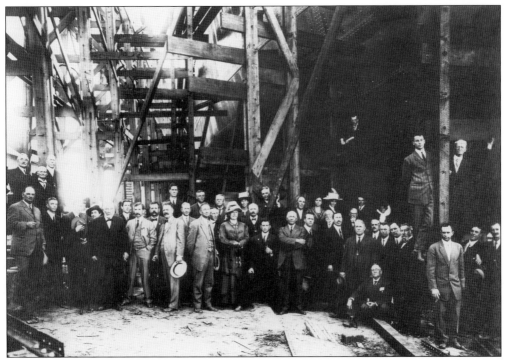

First Ship. Mayor Charles Windham (holding the hat), Jotham Bixby (second man to the left of Windham with white beard), and other of the town's movers and shakers attended the launching of the SS *General Hubbard*, the first steamship built at the Craig Shipyard in 1911 for Hammond Lumber. The steamship was named after Thomas Hamlin Hubbard, a Civil War officer and a business associate of C.P. Huntington. Hubbard served as the first vice president of Southern Pacific Railroad. Craig Shipbuilding became Long Beach Shipbuilding in 1914, then California Shipbuilding. The shipyard was located on 43 acres between Channel Three and Water Street. (Port of Long Beach.)

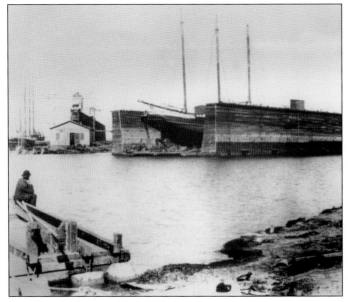

Dry Docks. The photograph shows a schooner ship in the Craig floating dry docks. The California Bankers Association held its 18th annual convention in Long Beach in 1912, and the Long Beach Chamber of Commerce took attendees via electric cars from the Hotel Virginia to the Craig Shipyard to show off the harbor developments. The attendees were returned in the evening for a Spanish barbecue at George Bixby's home on American Avenue in Rancho Los Cerritos. (Port of Long Beach.)

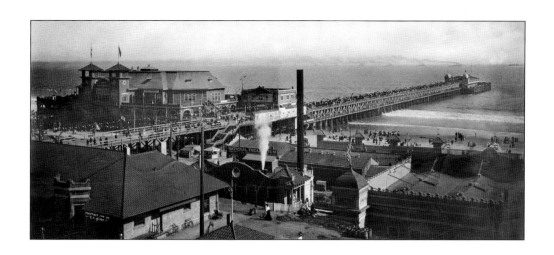

COURTING THE NAVY. As early as 1907, city officials traveled to Washington, DC, offering Long Beach as a base for the Navy because of "her port advantages." The city even offered to "donate the site if necessary." On December 16, 1907, Pres. Theodore Roosevelt sent 16 battleships and four destroyers, painted white with gilded bows, around the world to show US Naval power. From April 19 until April 25, 1908, the 2nd Division of the fleet visited Long Beach. More than 50,000 people lined up along the strand and on Pine Avenue Pier to greet the Navy. (Above, Library of Congress; below, Naval History and Heritage Command.)

NAVAL SHIPYARD BEGINNINGS. In 1911, the first war vessel to enter the Long Beach Harbor and the Craig Shipyard was the USS *Stewart* (DD-13), a torpedo boat destroyer commissioned in 1902. The boat was struck by another Navy boat during maneuvers off Santa Barbara and required repairs. A cement bulkhead was placed in the ship until it could sail to Mare Island for permanent repairs. (US Naval Historical Center.)

SUBMARINES. The fact that Craig Shipbuilding Company built submarines for the government in 1917, at a cost of $650,000 each, was used to bolster arguments with Congress for appropriations to improve Long Beach Harbor. *L-7* (SS-46), commissioned on December 1917, apparently became stuck in the silt in the channel, and Congress was lobbied for funds to dredge and remove the silt. (US Naval Historical Center.)

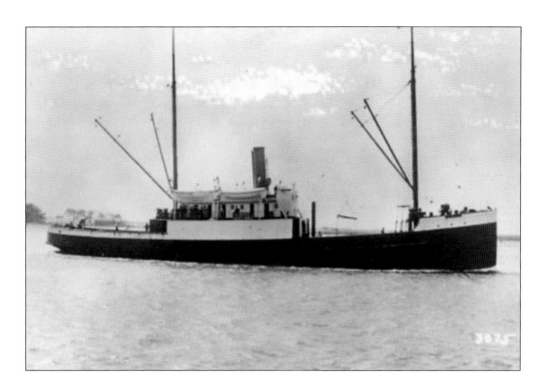

MUNICIPAL DOCK. Long Beach voters approved a bond in 1909 for harbor improvements and a municipal wharf. On June 2, 1911, the SS *Iaqua*, was the first ship to offload at the municipal dock with a shipment of 280,000 board-feet of redwood lumber from the Eastern Redwood Company in San Francisco. The local area lacked mature trees for lumber. The shipments would allow additional houses and other buildings. The opening of the $240,000 municipal dock was formally celebrated with a parade led by Mayor Charles Windham from Pine Avenue and Ocean Boulevard to Pier One. (Both, Port of Long Beach.)

INTERNATIONAL TRADE. The residents continued to approve bonds for the improvements of Long Beach Harbor to attract international trade, so that by 1919, the City of Long Beach had spent $2.15 million on developing a man-made Long Beach Harbor on its western borders. In 1931, the city completed construction of Pier One in the inner harbor. Long Beach was one of only cities in the United States to have its own wharf. (Port of Long Beach.)

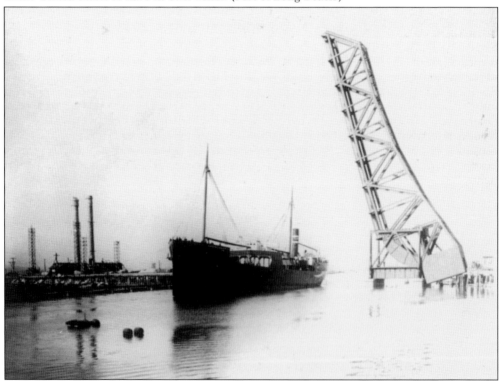

BASCULE BRIDGE. The landward side of the harbor was served by the Pacific Electric, Southern Pacific, and Salt Lake routes. A bascule bridge that contained rail tracks is shown spanning the harbor entrance. The bridge was one of the largest of its type and was constructed for $175,000. The Edison plant is visible to the left of the ship. (Port of Long Beach.)

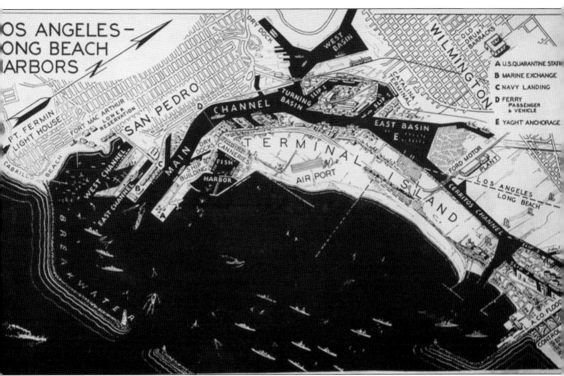

STORMS AND FLOODS. The Long Beach area was constantly hit hard by storms and flooding, particularly in 1867, 1873, 1884, 1889, 1891, 1911, 1913, and 1914. In 1911, the San Gabriel River, which normally flowed into Alamitos Bay, broke from its banks and joined the Los Angeles River five miles north of the Long Beach harbor. The storm carried tons of silt and materials into the harbor area, prompting officials to lobby the federal government for funds to construct flood control and an extension of the federal breakwater to protect the entrance to the harbor. Farmers in northern Long Beach lost much of their land due to the floods. The flood control construction to divert the Los Angeles River began in 1919 and was completed in 1923 by the Los Angeles County Flood Control District. This 1937 map shows the flood control on the lower right. (Port of Long Beach.)

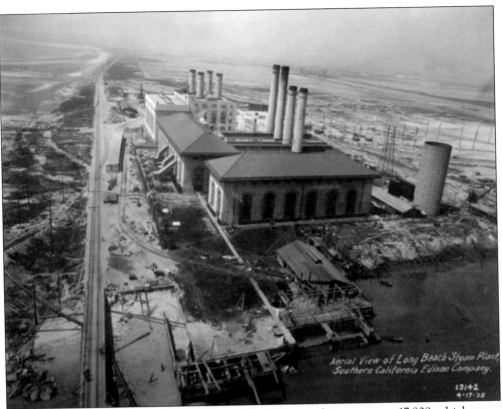

SOUTHERN CALIFORNIA EDISON. By 1910, Long Beach's population grew to 17,809, which was a 690.8-percent increase from the 2,252 in 1900. The press touted Long Beach as the "fastest growing city in the United States." As the city grew, it needed more electricity. In 1910, the Southern California Edison Company announced construction of a $12-million steam electricity-generating plant. Electricity was provided to Long Beach, Redondo Beach, Wilmington, San Pedro, Naples, Ocean Park, Venice, and Santa Monica. Boilers fueled by crude oil supplied steam to turbines, which produced electricity. The Edison Electric Company, which became Southern California Edison in 1909, had its Long Beach business office at Broadway and Pine Avenues. (Both, Long Beach Public Library.)

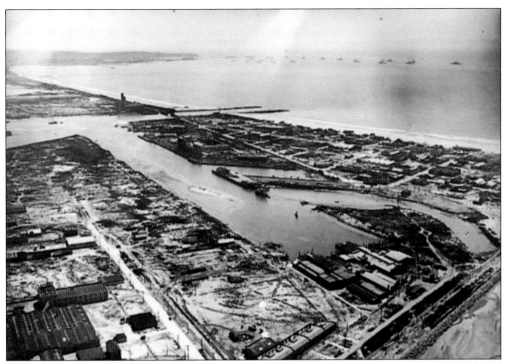

LOBBYING FOR A BREAKWATER. Mayor Windham wrote Congress in 1910 that "private capital and confidence shown by Craig Shipbuilding Company, the Southern California Edison Company, and Pacific Electric Railway Company" and a significant investment by the city in the harbor justified asking the government to "come to the assistance of the city." The mayor specifically asked for funds for "extension of the stone jetties [breakwater] to a point where the entrance depth of water would be 30 feet at low tide." (Port of Long Beach.)

SAFE AREA FOR VESSELS. Lobbying continued for an extension of the federal breakwater to the area between the opening of Long Beach Harbor and the flood control channel. Bulkheads, moles, and a 4,140-foot breakwater constructed by Long Beach were completed in the mid-1920s for a cost of $6.5 million. During the 1920s, the Navy anchored its Pacific fleet in San Pedro and Long Beach. The San Pedro breakwater made it possible for large commercial and naval vessels to operate in smooth water. (Port of Long Beach.)

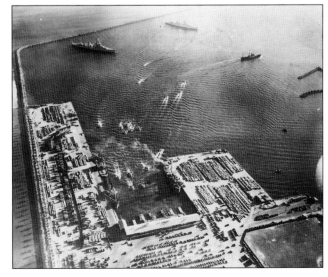

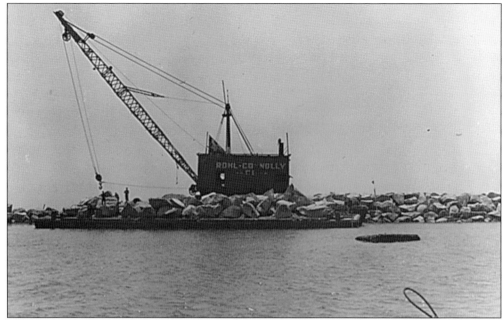

EXTENSION OF FEDERAL BREAKWATER. In 1930, President Hoover signed the Rivers and Harbors Act for funding of a $7-million, 12,500-foot extension of the federal breakwater from San Pedro to Long Beach. Congress debated whether or not Long Beach should receive funding, since it was so close to its neighbor, the Port of Los Angeles. Proposals to merge the two ports were discussed extensively but abandoned when the war started. The pictures show the rocks being placed in the ocean for the breakwater extension. Rocks were sent by train from Riverside quarries. When finished, the breakwater would give more than eight miles of protection to Los Angeles and Long Beach harbors. (Both, National Archives.)

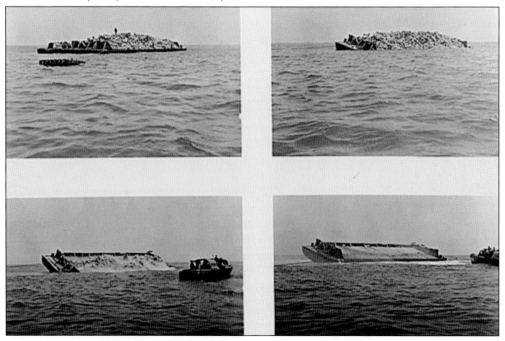

NAVY LANDINGS. Long Beach recognized the economic importance of having the Navy ported nearby. Fifty Naval vessels were anchored off the breakwater by 1932. More than 900 officers and their families lived in Long Beach, and an estimated 40,000 sailors came ashore to visit. A municipal Navy landing was built to accommodate the sailors and marines from the battleships anchored two to three miles offshore. The city's airport (Daugherty Field) served as the site of the Naval Reserve air base from 1928 until 1942. The aircraft carriers *Lexington* and *Saratoga* anchored offshore carrying 80 airplanes, which from time to time were flown to Daugherty Field for maneuvers. (Both, National Archives.)

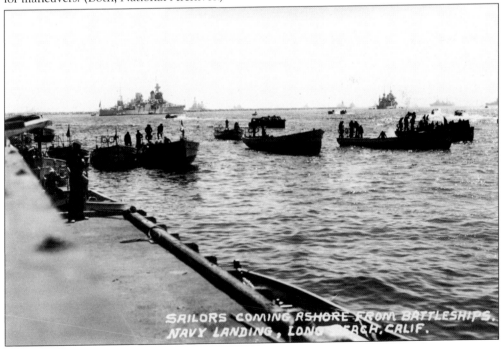

FACTORIES IN THE PORT. During World War I, Germany stopped providing potash (potassium oxide), a major ingredient in fertilizer, soap, and black gunpowder. Several potash-processing factories opened in Long Beach Harbor and used kelp to produce both potash and acetone. The Long Beach Salt Works plant (above) occupied 700 acres and processed 100 tons of salt a day. In 1931, the Procter and Gamble plant fronting Channel Two in the harbor produced soap, shortening, and other products from vegetable oils. Numerous canneries for fish and artichokes operated in the harbor, including the Long Beach Tuna Canning Company, which processed and canned whale tenderloin. Marketed as "the buffalo of the sea," whale meat sold for 15¢ a pound. Fishing fleets were anchored at San Pedro, Long Beach, and Terminal Island. Many were operated by Japanese Americans who lived in what was called the Fish Harbor on the south side of Terminal Island. (Above, author's collection; below, Library of Congress.)

Six

DISCOVERING
INCREDIBLE WEALTH

STRIKING OIL. The real estate boom, tourism, and the newly constructed port brought wealth and population growth to Long Beach. But nothing would compare with the impact brought by the discovery of oil and gas underneath and adjacent to the city of Long Beach in 1921. The oil field would prove to be one of the largest in the United States. Oil discovered in the harbor area in 1936 would provide the city even more wealth.

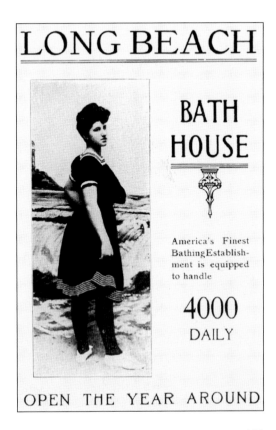

LONG BEACH

BATH HOUSE

America's Finest Bathing Establishment is equipped to handle

4000 DAILY

OPEN THE YEAR AROUND

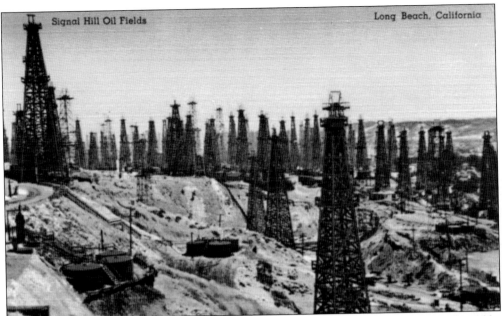

Signal Hill Oil Fields Long Beach, California

GUSHER. Drilling in the Long Beach area started in 1916, when hundreds of acres were leased by Standard Oil, General Petroleum, and others. After World War II, the government allowed foreign companies to drill, which brought the Royal Dutch Shell Oil Company to Southern California. On June 24, 1921, oil was struck at Shell Oil Company's Alamitos No. 1 well at Temple Avenue and Hill Street. Within a month, more than 14,000 barrels of crude oil were being extracted a day. A year later, wells in Long Beach and Santa Fe Springs were producing one-seventh of all the oil in the United States. The Long Beach oil field was drilled at the suggestion of Dwight Thornberg, son of a foreman on the Bixby Alamitos Ranch, who was convinced that oil could be located there. By April 1922, more than 30 oil companies were operating in the Long Beach oil field.

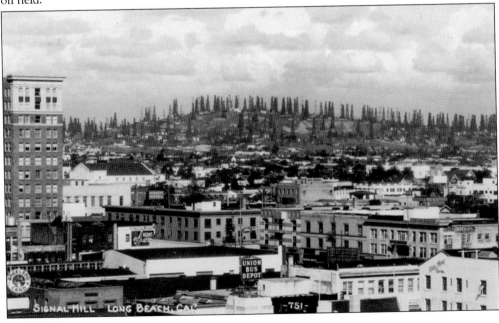

SIGNAL HILL, LONG BEACH, CAL. -751-

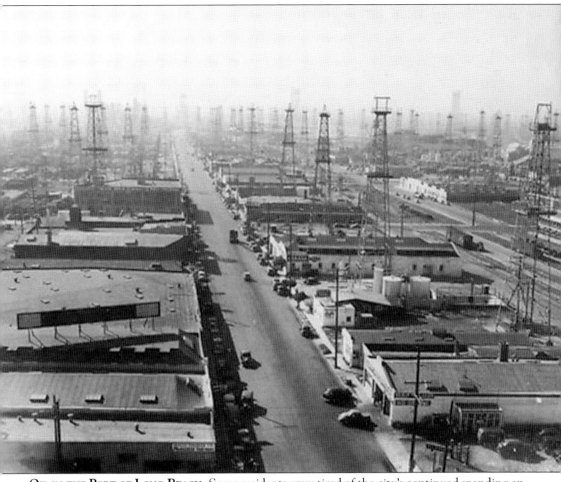

OIL IN THE PORT OF LONG BEACH. Some residents grew tired of the city's continued spending on improving the harbor and port. In 1922, they formed the Anti–Gold Brick Association of Long Beach and distributed literature opposing a bond issue for dredging and the purchase of property from the Dock and Terminal Company. But the discovery of oil in 1937 on port land would change many minds, as it became a steady source for additional port improvements. By 1938, yearly oil revenue from port drilling was $3.5 million. Major legal battles regarding the city's asserted rights to the oil revenues would result in the state taking 85 percent of the oil royalties and the City of Long Beach retaining 15 percent by 1965. So much oil would be extracted from the harbor area (which was 95 percent reclaimed land) that a large portion of the port area started sinking. The city would have to spend a large portion of its revenue to inject up to a million barrels of seawater each day to stop the subsidence. (Port of Long Beach.)

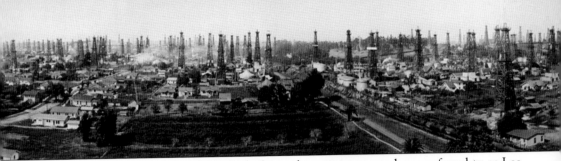

SIGNAL HILL. This panoramic photograph shows the unincorporated area referred to as Los Cerritos and Signal Hill, which was surrounded by Long Beach in 1923. When oil was struck, residents near the well in Signal Hill were forced to move, and were none too happy. Neither were the oil companies when Long Beach proposed to slap an oil production tax on the wells in the

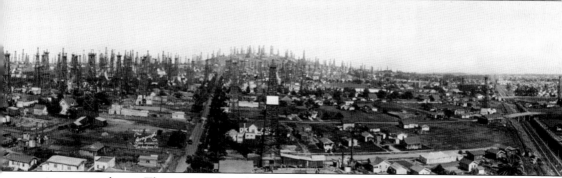

unincorporated area. This prompted residents to join with the oil companies to fight off being annexed by Long Beach, and in 1924, the City of Signal Hill was incorporated. Voters elected Jessie Nelson the first woman mayor in California. Signal Hill is less than 2.5 square miles but held more than 300 derricks, earning it the nickname "porcupine hill." (Library of Congress.)

MOVIE STUDIO. Long Beach and Signal Hill shared more than oil. In the early 1900s, Long Beach was home to the Balboa Amusements Producing Company (also known as Balboa Studios), one of the largest movie studios in California. Located on eight acres at Sixth Street and Alamitos Avenue in Long Beach, the studio used 11 acres in Signal Hill. Balboa boasted having the largest studio stage. After oil was discovered, the property became too valuable to lease for movie production. The studio was a major employer until it closed in 1921. Stars like W.C. Fields (whose home still stands on Ocean Boulevard), Buster Keaton, Mabel Normand, and Roscoe "Fatty" Arbuckle were a common sight in Long Beach. (Both, Library of Congress.)

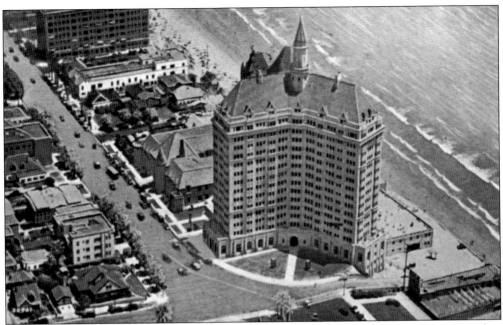

BUILDING BOOM. Numerous other oil wells "came in" on Bixby land on Los Cerritos and in Alamitos Heights. By 1929, oil and oil products were the number one shipping export at the port. The wealth generated from oil royalties for the city resulted in an explosion of spending on harbor development, city infrastructure and buildings, branch libraries, school buildings, and a hospital and the establishment of a municipal gas system, acquisition of additional land, and establishment of a municipal airport and Naval Reserve aviation base. Private wealth also grew, producing more banks, houses, apartments, theaters, department stores, social clubs, and hotels. Pictured above are the Pacific Coast Club (built 1925) and the Villa Rivera (built in 1929) at the corner of Ocean Boulevard and Alamitos Avenue. Below is the YMCA constructed in 1921 at a cost of $300,000 at Sixth Street and American Avenue.

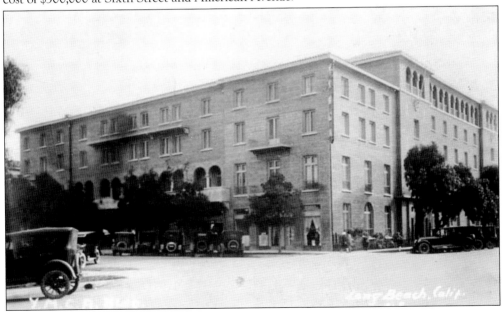

AUTOMOBILES. Interurban trolleys and railroads dominated transportation in Long Beach in the early 1900s. Automobiles quickly became popular. As early as 1904, dealers sold the Rambler sedan in Long Beach. A branch of the Automobile Club of America opened in the city in 1906. The electric vehicle, first produced and marketed in 1897, also found popularity in Long Beach. Local dealers sold the Baker electric vehicle (pictured), which traveled 50 miles on one battery.

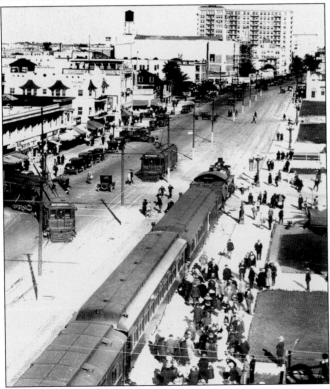

JITNEYS. In 1914, due to the economy and great dissatisfaction with the service provided by railways, owners of sedans operated jitneys. "Jitney" was slang for the nickel fare charged for a ride in these private cars. Long Beach City Council responded to the railways' complaints of losing riders by strictly regulating the operations of jitneys, charging a licensure fee and imposing a $10,000 liability insurance requirement. However, by 1922, most residents switched to using motorbuses for local transportation, and the tracks were eventually removed. (Long Beach Transit.)

Ford Plant. In the late 1920s, Ford told city officials in Long Beach of his interest to build an aircraft plant and encouraged the city to expand its airport. However, when the 35th Ford plant was built in 1930 adjacent to the Cerritos Channel in the port, it only produced automobiles. The Model A was made until 1921, when the plant switched to producing the V-8. (Library of Congress.)

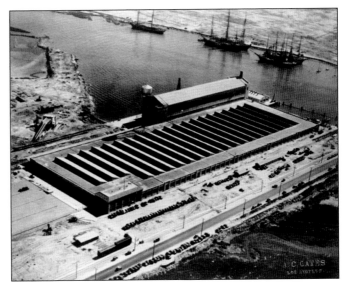

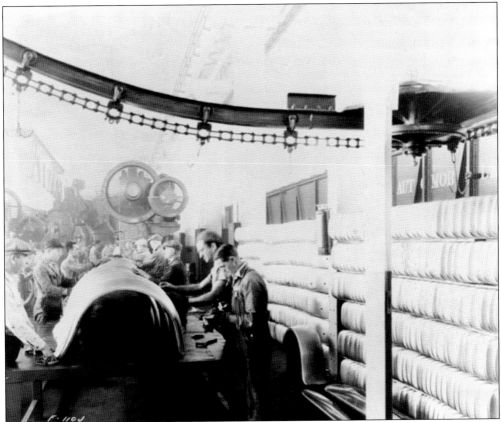

Autos to Airplanes. Ford assembly line techniques not only made automobile production cost-effective but also were utilized in the manufacture of airplanes. The Ford plant was closed from 1932 until 1934 and then used as an Army supply depot from 1942 until 1945. Oil was discovered under the Ford property. The removal of the oil caused major subsidence, and the plant began to sink. In 1959, Ford relocated to Pico Rivera, California. (Library of Congress.)

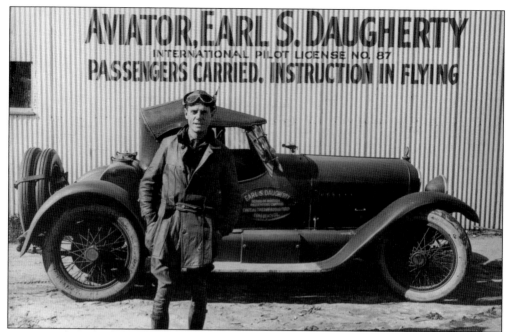

AVIATION FIRSTS. Largely due to local aviator Earl S. Daugherty, aviation flourished in Long Beach. Daugherty, a native of Iowa, became one of the first licensed pilots in the city in 1911. He maintained many connections with early flyers through his service in World War I as a flight instructor. His first private airfield was located at American Avenue and Bixby Road and was called the Chateau Thierry Flying Field. In the late 1920s, he moved to American Avenue and Willow Street, where he sold airplanes and provided flying lessons. (Long Beach Municipal Airport.)

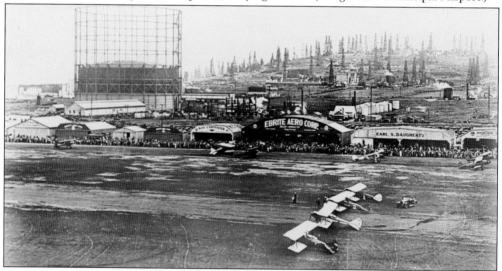

LONG BEACH MUNICIPAL AIRPORT. Realizing that Long Beach could no longer accommodate aviation on its beach nor on a small private airfield owned by Earl S. Daugherty, the city council in November 1923 dedicated 80 acres of water department land at Cherry Avenue and Spring Street for the Long Beach Municipal Airport. This made the city the first in California to establish a municipal airport. The airport was adjacent to the Long Beach Gas Department with its landmark storage tank. (Long Beach Municipal Airport.)

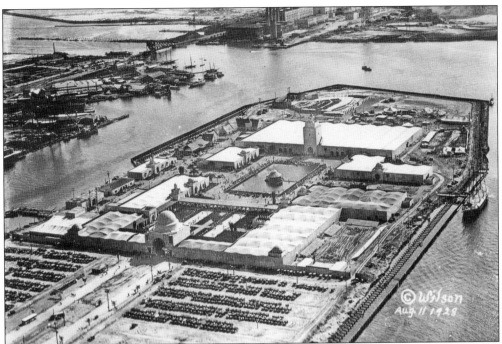

Pacific Southwest Exposition. City officials and the chamber of commerce proposed an international exposition be held in Long Beach from July 27 through September 3, 1928. A Congressional bill pledging federal support for the event was signed into law by Pres. Calvin Coolidge. Long Beach hosted the largest exposition in California since the 1915 Panama-Pacific Exposition in San Francisco and San Diego, drawing more than one million visitors to the waterfront.

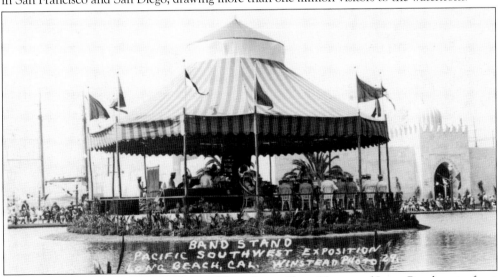

An Exposition March. Ten halls in a Moorish motif on 65 acres of Long Beach waterfront were filled with exhibits from cities throughout the Pacific Southwest as well as 33 countries. Airplane and dirigible demonstrations were featured. The Municipal Band performed the "Pacific Southwest Exposition March," composed by Herbert Clark. John Montijo, one of the city's first aviation commissioners and Amelia Earhart's flight instructor, flew several city officials across the state promoting the exposition.

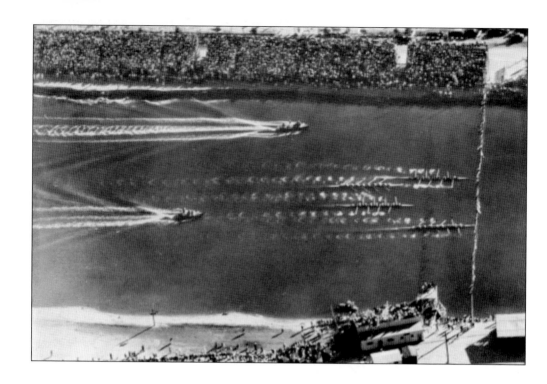

MARINE STADIUM. Long Beach dredged a channel in Alamitos Bay in 1925 in order to build a venue for the 1932 Olympic rowing races. The 2,000-meter course was the first man-made rowing course in the United States. Its width allowed four teams to race abreast, eliminating additional heats. The boathouse (shown) held showers and physician's quarters. The grandstand and bleachers held 20,000 spectators. The US team defeated Italy, Great Britain, and Canada, as shown in the photograph. The State of California has designated the Marine Stadium as a State Historic Site. In 1968 and 1976, it served as a site for Olympic rowing trials, and it remains an important training and competitive center for rowers.

ALAMITOS TRAFFIC CIRCLE. In preparation for the increased automobile traffic expected at the 1932 Summer Olympics in Los Angeles and Long Beach, the Alamitos Traffic Circle was constructed in 1930. It was expanded in the early 1940s. This roundabout is located at Lakewood Boulevard (formerly State Highway 19), Pacific Coast Highway (formerly US 101), Los Coyotes Diagonal, and Hathaway Avenue. The traffic circle was one of the first in California.

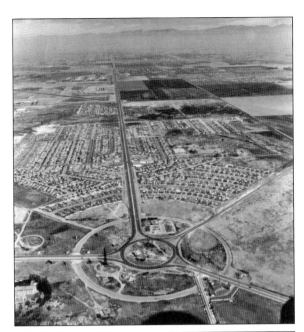

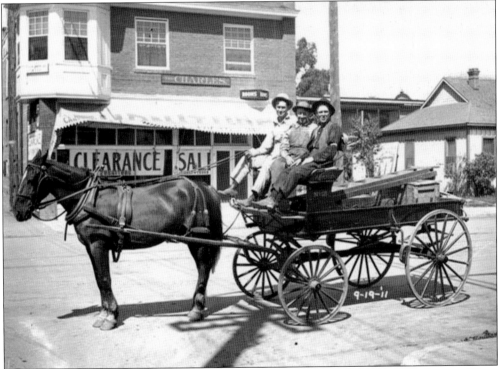

CITY WATER AND GAS DEPARTMENTS. The city purchased the Long Beach and Alamitos Water companies and established a water department in 1911. In 1916, the Southern Counties Consolidated Gas Company of California purchased the Long Beach Consolidated Gas Company (previously owned by Southern California Edison). In 1924, the city purchased the private company and established its own gas department. The photograph shows gas company workers in 1911. (Long Beach Gas and Oil Department.)

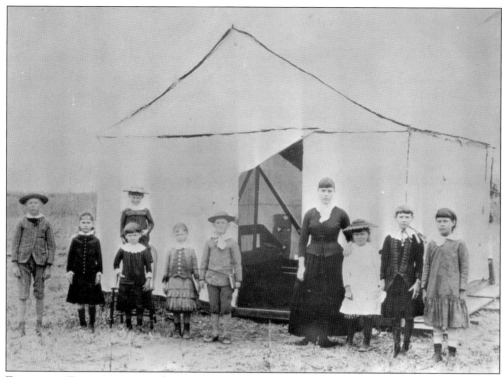

EDUCATION FIRST. Many years before the city acquired oil money, its residents focused on raising money for schools. In 1884, Belle Lowe solicited contributions for the area's first school. Initially established in a building at the southwest corner of Pine Avenue and Second Street, it was quickly moved to a tent at the northwest corner of First Street and Pine Avenue (pictured with 16-year-old teacher Grace Bush) and then to Pickle's Hall at Locust Avenue and First Street. (Long Beach Public Library.)

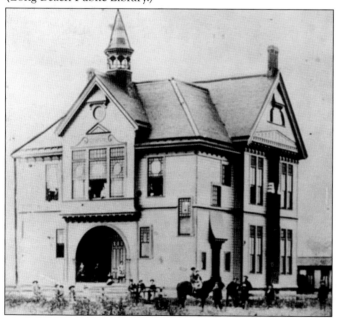

LONG BEACH SCHOOL DISTRICT. In 1886, a school was erected at Sixth Street and Pine Avenue. The county board of supervisors created a school district, and John Bixby, A.M. Hough, and Frank Butler were elected members of the board of education. Voters approved a second school at Hill Street and Atlantic Avenue that was named Signal Hill School. Later it was renamed Burnett, which was the name of the Salt Lake Railroad station nearby.

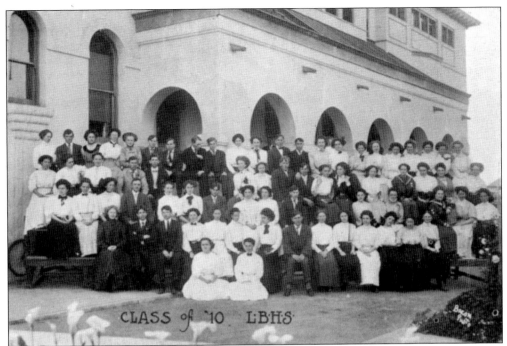

CLASS of '10 LBHS

LONG BEACH HIGH SCHOOL. By 1897, Long Beach had the following five schools: Central School, Pine Street Primary, Daisy Avenue, Alamitos School, Alamitos Heights School, and Burnett. The voters agreed that a high school should be built at American Avenue between Eighth and Ninth Streets. This photograph shows the class of 1910. The school was destroyed by fire in 1918 and replaced by George Washington Junior High.

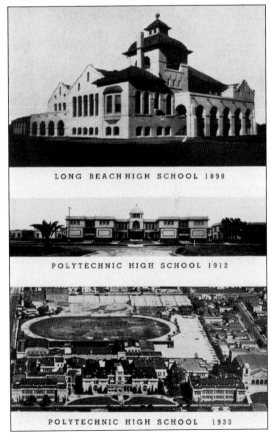

LONG BEACH HIGH SCHOOL 1898

POLYTECHNIC HIGH SCHOOL 1912

POLYTECHNIC HIGH SCHOOL 1933

POLYTECHNIC HIGH SCHOOL. In 1910, voters approved another bond to build a high school on 15 acres between Pennsylvania Avenue, Atlantic Avenue, Seventeenth Street, and California Avenue. Both academics and polytechnic training were offered. David Burcham served as the first principal. The school produced numerous celebrities, including early aviator Frank Hawks, who gave Amelia Earhart her first ride in an airplane after watching Earl Daugherty perform stunts in Long Beach. Hawks was a 1915 graduate.

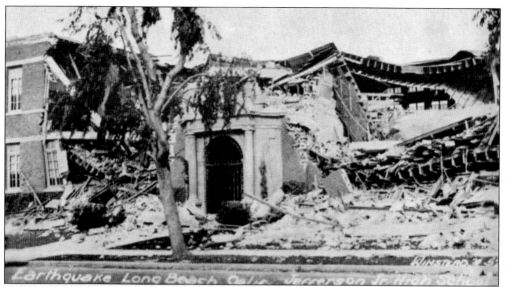

Earthquake Long Beach Calif. Jefferson Jr. High School

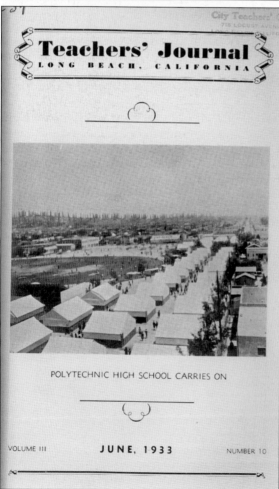

Teachers' Journal
LONG BEACH, CALIFORNIA

POLYTECHNIC HIGH SCHOOL CARRIES ON

VOLUME III **JUNE, 1933** NUMBER 10

LONG BEACH EARTHQUAKE.
Long Beach was hit hard by a
6.4-magnitude earthquake on March
10, 1933, at 5:54 pm. One hundred
and twenty people died (52 in Long
Beach), including five students in
the Wilson High School gym and
a firefighter, a motorcycle officer,
and a librarian. Most deaths were
from falling bricks and pieces of
buildings. More than 90 percent
of the Long Beach schools were
devastated and could not be
occupied for nearly two years.

CITY TEACHERS' CLUB. The City
Teachers' Club, a social organization,
was formed in 1913 and became the
Teachers Association of Long Beach
in 1954. Today. it serves as the union
for the Long Beach Unified School
District's 4,000 teachers. The cover
of the club's journal in June 1933
shows the tents where classes were
conducted for two years following the
earthquake. Other schools met in
parks. Lessons were also broadcasted
over the following two local radio
stations: KFOX and KGER.

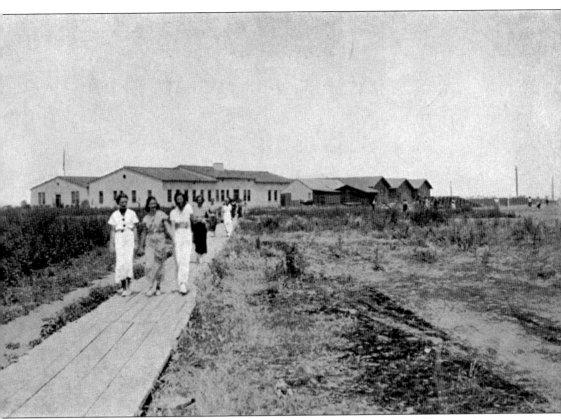

ADDITIONAL SCHOOLS. In 1926, Woodrow Wilson High School opened at Ximeno Avenue between Eighth and Tenth Streets. Wilson was severely damaged from the earthquake. Long Beach Junior College was located at Wilson High School until 1935, when it moved to its own campus on Carson Avenue. In 1949, a Pacific Coast campus of the college was established on the former site of Hamilton Junior High. Long Beach schools owned oil-rich properties in Signal Hill, which funded the building of the district administration building on Locust Avenue near Seventh Street. Long Beach opened another high school that was named in honor of naturalist and peace activist David Starr Jordan in September 1933. The school was first located at the North Long Beach YMCA at Sixty-First Street and California Avenue. The new site (pictured) opened for students in 1935 on Atlantic Avenue.

OIL MONEY AND POLITICS. In 1934, Long Beach resident Frank Merriam (left) defeated Upton Sinclair (below) and became the first Long Beach resident elected governor. Merriam's race was one of the dirtiest political campaigns of its time. He was assisted by movie producers and newspaper publishers who used their resources to smear Sinclair, an author and political activist whose book *Oil* took on the industry. Merriam previously served as lieutenant governor and in the assembly and state senate. Governor Merriam sent National Guard troops to quell the longshoreman strike at the San Francisco docks in 1934, resulting in several deaths. The event was referred to as Bloody Thursday. Merriam lost reelection in 1938. (Left, author's collection; below, Library of Congress.)

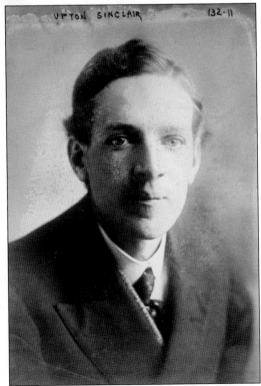

UPTON SINCLAIR 132-11

The Author. Gerrie Schipske's parents met at the Pike in Long Beach in 1947. Her father, Norman, a native of New Jersey, was an 18-year-old US Marine assigned to the USS *Topeka*, which was anchored in Long Beach. Her mother, Mary, a 17-year-old transplant from Pennsylvania, came with her family to California in search of employment. They married at St. Lucy's Church on the Westside of Long Beach and first lived at Truman Boyd Manor, a housing complex named in honor of a local World War II hero. Born in 1950 at the Long Beach Naval Hospital, Gerrie later received degrees in liberal arts, history, legislative affairs, nursing science, and law from Fullerton College; University of California, Irvine; George Washington University; Goldenwest College; and Pacific Coast University School of Law. Elected to the Long Beach Community College District Board of Trustees in 1992, she was also elected to the Long Beach City Council in 2006 and 2010. Gerrie Schipske is the founder of the Long Beach Rosie the Riveter Foundation and the author of two other Arcadia publications, *Rosie the Riveter in Long Beach* and *Early Aviation in Long Beach*. (Official photograph.)

DISCOVER THOUSANDS OF LOCAL HISTORY BOOKS FEATURING MILLIONS OF VINTAGE IMAGES

Arcadia Publishing, the leading local history publisher in the United States, is committed to making history accessible and meaningful through publishing books that celebrate and preserve the heritage of America's people and places.

Find more books like this at
www.arcadiapublishing.com

Search for your hometown history, your old stomping grounds, and even your favorite sports team.